THE oil paint
COLOUR WHEEL BOOK

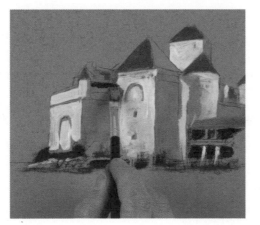

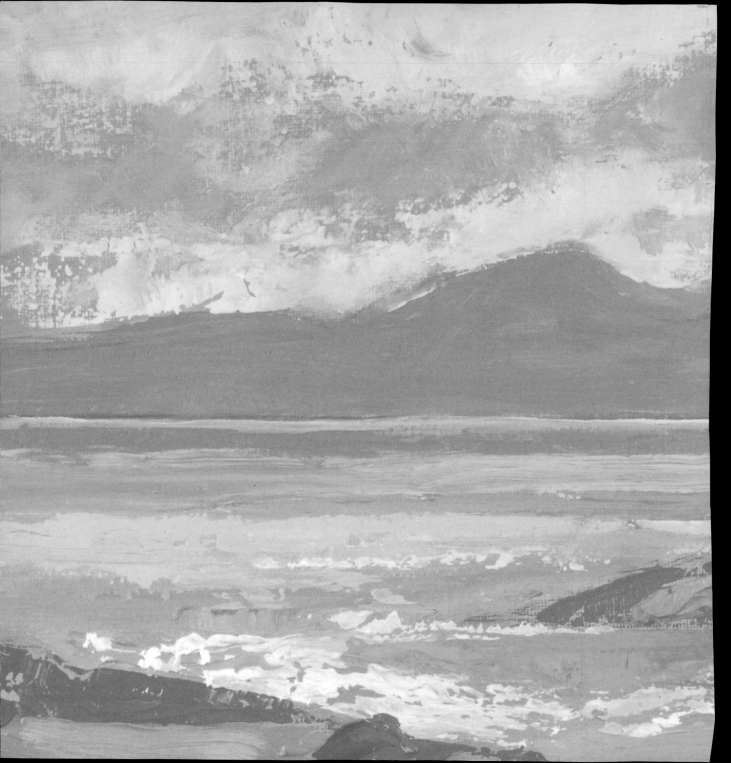

THE oil paint
COLOUR WHEEL BOOK

john barber

Search Press

First published in Great Britain in 2009 by
Search Press Limited
Wellwood, North Farm Road
Tunbridge Wells, Kent TN2 3DR
Reprinted 2010

Copyright © Axis Publishing Ltd

Created and conceived by
Axis Publishing Ltd
8c Accommodation Road
London NW11 8ED
www.axispublishing.co.uk

Creative Director: Siân Keogh
Editorial Director: Anne Yelland
Designer: Simon de Lotz
Production: Jo Ryan
Photography: Sean Keogh

ISBN: 978 1 84448 428 7

The publishers and author can accept no responsibility for
any consequences arising from the information, advice
or instructions given in this publication.

Readers are permitted to reproduce any of the material
in this book for their personal use, or for the purposes of
selling for charity, free of charge and without the prior permission
of the Publishers. Any use of the material for commercial purposes
is not permitted without the prior permission of the Publishers.

Suppliers
If you have difficulty obtaining any of the materials or
equipment mentioned in this book, please visit the Search Press
website for details of suppliers: www.searchpress.com

Printed and bound in China

contents

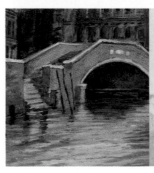

A simple subject and a
limited palette can create
an effective painting. Tint a
ground and use this as
one of your three tones.

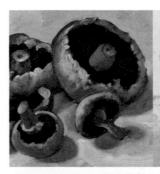

Create a convincing
sketch using translucent
washes, then add white to
your colour mixes to pick
out highlights.

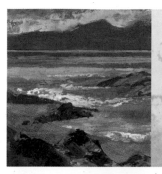
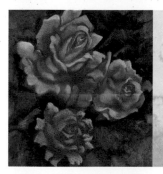
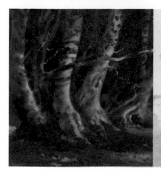
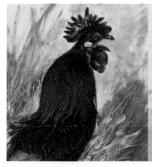
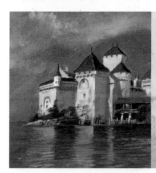
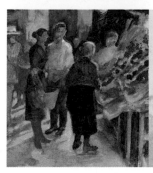

introduction

Many people are deterred from using oil paints by the seeming complexity of the medium. This book sets out to dispel the mystique surrounding oil painting and to provide a straightforward guide to those who are starting with the medium. It describes how to use the variations or formulas that enable oil paints to be used in so many ways.

All you need to get started are colours in tubes, rectified turpentine to dilute them and a few hoghair brushes. These can be used to paint on a wide variety of surfaces that will take paint and do not absorb oil.

Through the equipment and technical pages within the projects , the technical aspects are described and demonstrated. Different combinations of diluents, surfaces and brushes alter the handling characteristics of the paint dramatically. All these 'tricks of the trade' are described in clear practical terms enabling you to arrive (when your skill matches your aims) at a method that suits you.

Oil painting, more than any other art medium, has a large craft element which requires you to become accustomed to your materials and how to select and handle them with confidence. This is one of the great fascinations and a source of endless surprises and delights.

The exact date of the first use of pigments ground in oil is impossible to determine with any certainty. The decorations on some Egyptian tomb furnishings seem to have run after the tombs were sealed, suggesting that slow-drying oils or resins had been used. The fragments of paint that still adhere to some Greek sculpture after 25 centuries seem to indicate something more durable than tempera, but oils were certainly experimented with for some centuries before the Van Eycks, who are often credited with the 'invention' of oil painting, in the 15th century. They still depended on the influence of a pure white ground and a tempera underpainting to give their work its jewel-like clarity of colour. Nut oil and resin, would have enabled them to achieve their miraculously detailed work.

Their work is a perfect example of what is sometimes referred to as the 'transparent method'. In this method, composition and pattern of light and shade are drawn accurately on the picture before any colour is added. Pure colour without the addition of white is then applied over the dry underpainting. This method allows form to be separated from colour and gives the most brilliant colours.

In the 'mixed method', transparent shadows are left so that the underpainting or background colour shows through to influence the final picture. The light areas are built up with solid colours made opaque by the addition of white.

The third and by far the most popular way to paint using oils is the 'opaque method'. All colours have white added to them to achieve the desired level of tone. Each layer of paint covers the previous one and alterations are made by painting over existing colour areas. It gives tremendous freedom to overpaint and change shapes and colours. This was the method of the Impressionists who, in their search for immediate effects of light, painted in many layers of colour

THE COLOUR WHEEL

The colour wheel is great reference for artists. The three colours in the centre are the primary colours. Primary colours are the ones that cannot be obtained by mixing other colours together. The middle ring shows the colours that are created when you mix two of the primaries. Red and yellow makes orange; blue and yellow makes green; blue and red makes purple. These are called secondary colours and show the colours you can expect to create when you mix primary oils in your palette. All colours can, in theory, be created by mixing varying amounts of the primaries. The outer ring breaks down the secondary colours further into 12 shades.

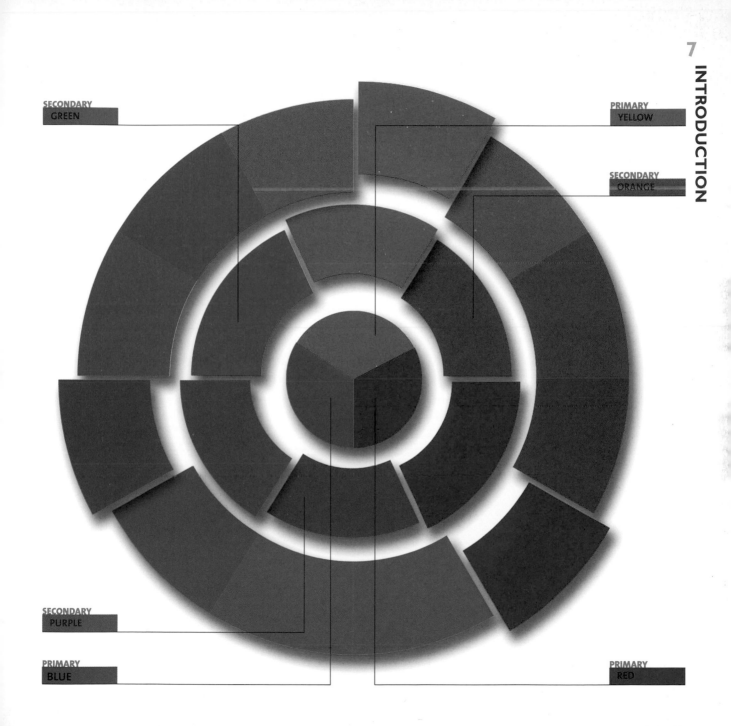

SECONDARY
GREEN

PRIMARY
YELLOW

SECONDARY
ORANGE

SECONDARY
PURPLE

PRIMARY
BLUE

PRIMARY
RED

COMPLEMENTARY COLOUR

The colours that are opposite each other on the colour wheel are called complementary colours. These work together to create a harmonious reaction. Try using them side-by-side in your work – they will each appear to be stronger by contrast, bouncing off each other.

COLOUR TERMS

HUE

Hue indicates the strength of a colour from full saturation down to white. In practical terms, if you buy any colour labelled 'hue' it means that the colour is less than full strength. This is used as a way of reducing the cost of expensive pigments.

TONE

Tone is the degree of darkness from black to white that creates shade and light. For example, in a black-and-white photograph you can see and understand any object independently of colour, solely by its graduation from light to dark. The word 'shade' is often used instead of 'tone'.

COLOUR

Colour results from the division of light into separate wavelengths, creating the visible spectrum. Our brains interpret each wavelength as a different colour. The colour wheel is an aid that helps us understand how colours are arranged in relation to each other.

TRIADIC COLOUR

Triadic colour occurs when a 'chord' of three colours is used in combination. A mixture of any two colours of the triad used next to a third, unmixed, colour will give many different effects. A triad of colours from any part of the wheel is the basis for a good colour composition.

SPLIT COMPLEMENTARY COLOUR

Split complementaries create three colours: the first colour, chosen from any point on the wheel, plus the two colours that come on either side of the first colour's natural complementary colour. These three colours will give plenty of unexpected colour schemes.

using the primary colours and dispensing with the traditional use of browns and blacks to create shadow. The invention of flexible metal tubes to contain paint made possible the creation of finished works done in the open air. This is the practice of many landscape artists today.

By using only the primary colours, the best Impressionist paintings achieve a spirited, luminous, vibrant surface. For landscapes on a moderate scale, as most Impressionist work is, the opaque method works perfectly. Broken colour, leaving a rough surface and showing brushmarks, gives a bright lively finish that readily reveals a painter's artistic personality.

The possibilities of experimenting in oil paints can lead to technically unsafe pictorial 'concoctions'. Try different ways of working, but be aware that the wonderful variety of ways you can use to develop your personal style do have some rules of best practice which it is unwise to ignore if you wish your painting to preserve your original intentions as long as possible (several hundred years if you get it right).

the basic rules
• Use a solid white ground on a canvas or panel, either a bought surface or one you have prepared yourself. Cover it with a light transparent tint if you wish.
• Use as little diluent (usually turpentine) as you need to get the paint moving as you would wish. Start with very little or no oil in your mixing, adding more linseed oil as the painting progresses. 'Start lean, finish fat' is the usual rule of thumb, borne out by research and the many paintings that have failed by ignoring it. Painting colour containing little oil over areas that are rich in oil will cause cracking, which although less important in modern styles of painting, can still be displeasing. The master of paint manipulation, John Singer Sargent (1856–1925) frequently added his pure black accents as the last touches in his paintings and these areas often show a fine network of

light lines because they were put onto paint that was not dry. Black oil paint is a thin colour which, if mixed with oil, can become transparent, so perhaps this explains the slight technical fault that occurred. If you can get the effect you want in one session, without overpainting, sometimes called 'alla prima', these difficulties will rarely bother you.
• Limit your palette: a gamut of colours will confuse.

INDOOR/OUTDOOR TEST

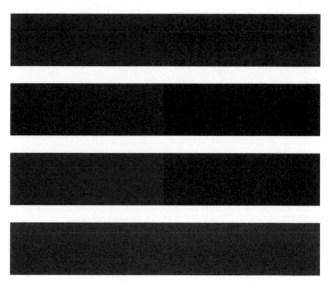

The indoor/outdoor test is designed to show the effect that artificial or subdued lighting has on colours when compared to daylight. If you look at the four strips indoors you can see hardly any difference between the colours on the right compared to the ones on the left. Step out into the daylight and you will be able to see that the right-hand side is noticeably darker. This sort of phenomenon plays an important part in how we perceive colour and all artists have to be aware of it. Although it is never quite as obvious as in the experiment, it does help to explain why art studios are built with high skylights, ideally facing north. For artists whose pictures depend on great colour accuracy, good daylight is an essential need.

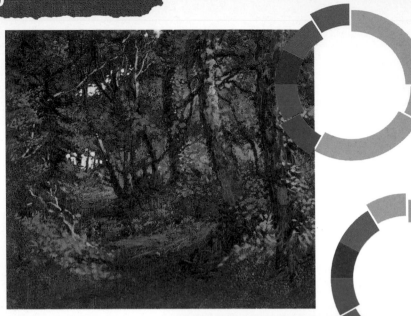

Pale sunlight, misty atmosphere and lights twinkling in the gloom blur the details of boats and buildings and the subject matter becomes only a starting point for a study of light on water. These barges on the Thames below Westminster Bridge act as a foil to the sparkling water painted in a range of closely related cool colours, with hints of the sun's warmth in the pinks. Here the violet and permanent rose from the colour wheel provide a range of tints for the reflections that influence the colour temperature throughout the picture.

Painted deep inside a wood, with the sunlight filtering through the thick foliage, this picture depends for its effect on the control of the light patches and their placing in the scene. Careful combinations of mixed greens and blues cover the larger part of the picture, but it is the bright, almost pure cadmium lemon spots that add the sparkle and interest. The yellow-green-blue range from the colour wheel saturates the scene with only the appearance of the warm reds, introduced as burnt sienna in the foreground, to accentuate the greens by the contrast they provide.

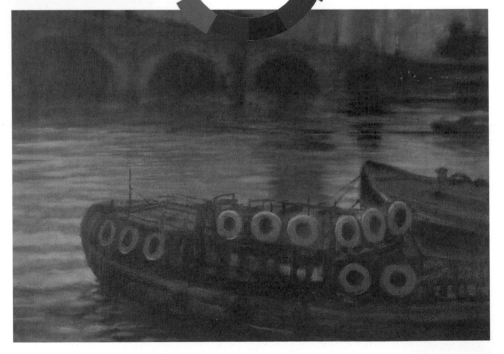

The Wildstrübel, which translates as 'tousled head' because the mountain always seems to have a wreath of clouds around its peak, was painted from a mountain house across the valley. In contrast to the Thames painting, the light and air were crystal clear and the whole range of blues and violets crisp and defined in clear patches. The clouds rising from the valley floor were scumbled on after the rest of the picture was dry, a technique often needed in this sort of oil painting to avoid blurring existing details.

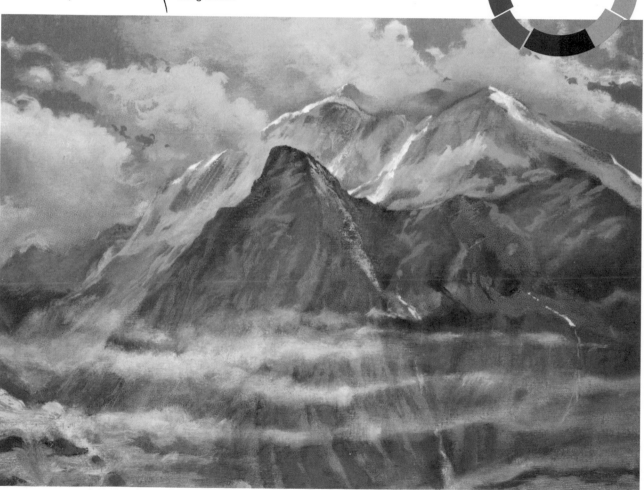

how to use this book

The jacket of this book features a unique colour-mixing wheel that will show you the shade that will result when you mix equal quantities of two colours. The colours have been chosen as the ones that are most useful to artists working in oils. A glance through the projects in this book will give you an indication of the enormous range of colours and tones that can be achieved using these colours. Each project lists the colours you will need and highlights how to mix them to achieve the shades used in the project.

USING THE COLOUR-MIXING WHEEL

The colour-mixing wheel can be used to help you determine what the result of mixing any two colours from your selection will be. It can also be used if you are unsure of how to achieve a shade you wish to create, from nature for example. Turn the wheel until you find a shade in one of the inner windows you like and read off the two colours you need to mix to achieve it.

outer colour wheel
The colours on the outer wheel are the standard oil colours you will need to get started.

inner colour wheel
Colours on the inner wheel repeat those of the outer wheel.

mixed colour
This window reveals a swatch of the exact result of mixing equal quantities of the colours on the inner and outer wheels.

turn the wheel
The wheel turns so that you can line up the two colours you intend to mix and see the result in the window.

finished painting
The project begins with the completed painting to give a sense of its overall scope and complexity. This is then broken down into several steps, gradually building the work.

picture details
The title of the finished piece of work, together with the artist's name are given. Also included is the size of the work, to give you an indication of scale.

what you will need
All the materials and equipment you will need to complete the project are highlighted at the start so that you can have everything to hand.

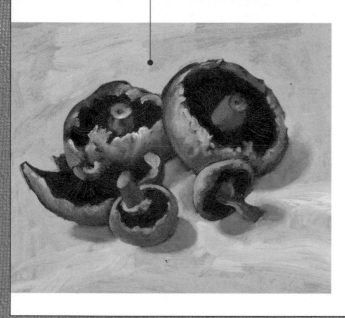

1
mushrooms still life

john barber
220 x 315mm (8½ x 12½ in)

This is a very limited palette still life, worked using only browns and greys, to demonstrate how far you can get into an oil painting without using white. This will help you to concentrate on the importance of the actual tone between dark and light without having to pay too much attention to the complications of colour mixing. When you have chosen your subject matter, bear in mind the fact that you will not be using white until well into the project when you start to tint your canvas. In this case a stippled effect has been left in the background tinting – this gives a sympathetic ground on which to build colour and to model the subject, a simple grouping of mushrooms.

TECHNIQUES FOR THE PROJECT

Using three tones

Working on a tinted ground

WHAT YOU WILL NEED

Tinted canvas
Conté crayon
Brushes: flat hoghairs nos 3, 5, and 9
Turpentine
Rag

COLOUR MIXES

1 Payne's gray
3 Burnt sienna
4 Yellow ochre
12 Ultramarine

techniques for the project
Different techniques are used in every project to build up your experience and confidence.

colour mixes
The colours used in the project are shown, together with the colours they are mixed with, to create the finished work.

14

project techniques
Each project begins with an explanation of one of the main techniques that will be used to create the picture, with notes to help you to achieve good results when using it.

detailed working
Close-up photography allows you to see every line and mark the artist makes to build up the practice study.

54

mushrooms still life / techniques

55

PROJECT 1 / MUSHROOMS STILL LIFE

MAKING MARKS

This little study demonstrates just how much drawing and modelling can be done simply by using the slow-drying qualities of oil paint which allow the paint to be moved about for a long time. The instruments or tools you use to scratch through the paint will depend on your own interpretation of the texture you see in your subject matter. knives and brushes are obvious tools to start with, then experiment. Georges Braque (1882–1963) used steel combs made for imitating wood grain in his Cubist paintings. Seeing this, Picasso (1881–1973) used his own hair comb to texture his paint. Keep an open mind and try whatever you feel like. You will be introduced to

using a simple version of this technique in step 2 of the project that follows, but work a few simple studies like the one here to build up your knowledge of how paint handles.

In the six photographs on these pages a small palette knife is used to make a wide variety of marks and it is perhaps wise to master the control of one tool before moving on to widen your range. You need not copy the technique drawing but can use your understanding of what is being done here to start you experimenting with other colours and other types of marks. If this little study had been started with red instead of green, the result might have suggested a flower rather than a vegetable.

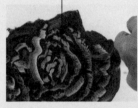

3 Now start in the middle of your patch and make some small concentric marks, working outward. Try to use the flexibility of the knife to make smaller marks by using less pressure. This time try bringing the blade toward you.

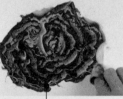

4 As you begin to get the feel of the knife working on the surface of your canvas or board, you will be able to make a greater variety of marks and control their shape. You will also begin to get a feel for the thickness of paint you prefer.

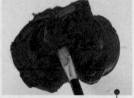

1 Mix up a colour on your palette using it as it comes from the tube. Don't dilute is as this exercise needs some thickness of paint. Spread it around with a hoghair brush to make a random shape. Leave any marks or texture.

2 Take a small trowel-shaped and flexible palette knife. Press the blade edge onto the paint and gradually push it away from you, increasing the pressure so that more paint is cleared at the end of the stroke. Wipe your knife clean each time.

5 Draw in some fine crinkly lines using just the tip of the knife. Begin to really draw with your knife – you can use a brush handle to make marks if it is easier. The paint that is pushed away becomes an outline of the shape you have cleared.

6 Fill four patches of colour with marks, sometimes overlapping them. If you drag your knife outside the shape you will make lines onto the background. If some suggest a subject, keep them. If not, they can be wiped away with a rag.

practice sketch
Each techniques spread features a quick step-by-step study enabling you to practise the technique.

finished study
The study builds into a finished sketch. You could practise this several times in different colours before embarking on the project.

step by step
The project is built up in detailed steps right from the first sketched marks to the finished piece of work, enabling you to create a work of your own using these techniques.

detailed practice
Practical photographs of good working practice in using materials show the artist building up the work.

58

1

mushrooms still life

Add a light scumble to the dark areas of shadow. The shadow should be transparent.

RIGHT Although you are putting on pure bluey-grey here, this will be modified by the colour of the tinted canvas. The background colour of the canvas will play an important part in this composition.

RIGHT Continue to create areas of shadow, where they fall around the mushrooms.

Mix the tints for the body of the mushrooms using white, yellow ochre and a touch of burnt sienna to warm it. Add a little ultramarine to one area of this paint mix so that you have a warm grey and a cool grey on the palette. Use the power of the white paint to lift the painting away from the tinted background.

Work around the lightest areas of the mushrooms, that is, their edges. Using the white-tinted paint starts to lift the composition from the canvas.

STEP 5

STEP 6

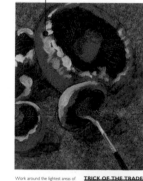

TRICK OF THE TRADE
When blending your light patches of paint into the middle tone, use a clean brush and wipe it on a clean rag between each stroke. This will avoid lowering the tone of your lights. If the paint does not blend easily add a little clean turpentine to your brush and use this to help.

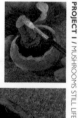

RIGHT For the bottom of the stem add burnt sienna to your lightest colour mix. This warms the colour, making it ideal for this earthy area of mushroom.

Add this same colour mix to other areas of stem. Work around all the cut stems, adding this colour mix to these areas. Blend with your finger, then work some dark accents to the underside of the mushroom using burnt sienna.

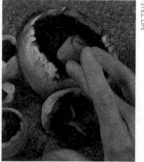

59

PROJECT 1 / MUSHROOMS STILL LIFE

STEP 7

STEP 8

pull-out detail
For clarity, some areas of the work are highlighted in greater detail, enabling you to see exactly what shade or effect you are looking for.

clear steps
Each project builds up in numbered steps, with precise details on what to mix and how to add colour and detail.

artist's advice and tips
A practising artist offers information and advice based on his experience of materials and equipment and methods of working.

guided steps
All the steps are clearly outlined, as the project builds up. Following all the steps results in the finished picture.

materials & equipment

Artists in oils choose their materials and equipment carefully. This section examines the range of materials you will find in your art store or online and explains what you need from this array in order to achieve successful results. Paints, supports, brushes and knives, mediums and accessories are fully illustrated.

materials and equipment

Oil paints in collapsible tubes have been the preferred way of marketing and storing oil paints since the middle of the 19th century when the now-familiar screw caps were patented in 1841 by an American, John G. Rand. He claimed that the tubes would preserve the colours for several years and indeed good-quality modern colours as constituted for sale in tubes will last almost indefinitely providing that you wipe the metal thread clean and screw the cap tight. Paint in tubes that are 20 years old seems to be unchanged in colour and handling qualities. If you do find that a tube colour has dried, try cutting out the dried crust around the cap, squeeze out the dried paint, clean the cap and replace. The remaining paint in the tube will be unaffected.

choosing colours

The range of colours from many makers is so wide that it is not possible to review them all here. Choose a make that you like and supplement it with specific colours from other makers if you need to. Before you buy your paints think about the size and number of pictures you are likely to be painting. Very large tubes are probably not needed, but buying the largest tube of white (the most used colour) is a good investment. Titanium white is best for most purposes. There are specialist whites available but, unless you find that titanium white will not do exactly what you want, you need not investigate them. Most oil paints on the market are reasonably permanent and the better makers mark a code for permanence on their tubes.

Most pigments in tubes are ground in linseed or poppy oil. If you wish to control or reduce the amount of oil you can do this by squeezing the paint out onto a pad of newspaper overnight. The medium (liquid) used to dilute your paints will have more effect on the way you paint than the painting surface or even the quality of the paint, so adding your own mixing liquid to the drier paint can give more control over its viscosity and handling.

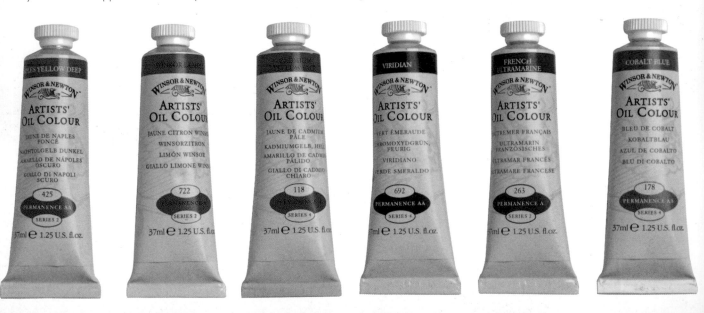

LEFT The viscosity of oil paint makes it so versatile. It can be used straight from the tube for most purposes and applied with a brush or knife as thickly as you wish, or thinned to move as easily as a watecolour wash.

BELOW It is not necessary to have a vast number of tubes of colour to create successful paintings. Think about the sorts of works you might like to paint, choose up to a dozen 'basics' and add to them as necessary.

LOOKING AFTER YOUR PAINTS

You do not need to buy a large and expensive box to hold your paints, but it does make sense to store them together, unless you are fortunate enough to have a room that you can dedicate to your painting. Any large strong container with a lid will be fine. If you do buy a box, choose one with indentations to keep tubes separate. Boxes with two or three separate trays or drawers to hold paints, brushes, knives and mediums are a good choice.

If you are going to work outdoors, or want to carry your paints with you, an artist's box set of paints is a good investment. Take weight into consideration if you are going to carry your paints any distance. A box that holds perhaps 10 to 12 small tubes, some brushes, a couple of knives, a palette and medium may be all you need. A useful additional feature is a holder for wet artwork so that you can carry your painting home.

grounds or supports

You can paint in oils on a wide variety of surfaces, as long as they are prepared properly. These pages present the most common and then offer a few pointers on less usual surfaces that can also be used successfully.

canvas

Canvas is the most popular surface with oil painters. The finest and most expensive canvases are made from linen but cotton, which was introduced later and is not quite so durable, is also excellent as a support. Both these materials are produced in grades from very fine, where the threads of the weave hardly affect the painting surface,

to really coarse textures that break up the paint into dots. For extremely large areas, such as scenery painting, hessian is often used as a cheap alternative to canvas. Canvas is usually supplied tacked to light wooden frames that can be tightened by tapping small wedges into the corners. You can also buy canvas by the yard, or by the roll and stretch it yourself. Some online suppliers offer precut and stretched canvas to personal measurements.

Canvas boards are widely available in all grades and sizes. They are made by gluing canvas to a heavy cardboard base and are a convenient and light alternative to stretched canvas for small- to medium-sized works, up to approximately 600 x 500mm (24 x 20in): larger-sized

boards have a tendency to warp. Canvas boards can be cut down to a smaller size with a craft knife if you wish to alter your composition.

panels

Large wooden panels, which were in use before canvas became popular, were always unstable as a support and very expensive to make. Masonite was often used as an alternative, but this has been superseded by an excellent modern replacement material, MDF (medium density fibreboard). MDF is inert, does not warp, does not attract insects and if properly sealed and primed, is a fine support for all artists who prefer a smooth surface to work on.

LEFT Canvas, tacked to a stretcher for tightening, is available in many sizes and is usually sold primed and ready for painting. Canvas boards too are sold in many different shapes and sizes, from postcard size up. You can always cut a larger panel down for smaller studies. Boards are also usually primed and ready to paint on, as long as you are happy to paint on a white ground. If not, tint the board.

RIGHT Papers suitable for oil painting are sold as individual sheets and in pads of many different sizes and weights. A good general weight is 250gsm (150lb). These are ready to paint on immediately. Other papers need sizing and priming before oil paint is applied.

When primed with gesso (plaster and glue) it provides a surface comparable to those used by the masters of the 15th and 16th centuries.

paper and card

Paper and card are delightful to paint on and provided they are sized with glue to prevent oil soaking into them, are technically sound. Most oil paintings and sketches by Toulouse Lautrec (1864–1901) were done in this way. Papers are available in individual sheets and in pads, in several sizes.

other surfaces

Many fine pictures have been painted on copper and aluminum, provided that it has a slight 'tooth', can also be used. Glass also makes a good surface.

brushes

The most popular brushes for oil painting are made from hoghairs. These are stiff yet springy and will either smooth the paint into place or plough through the paint to move it. They are made in many shapes and sizes: round, flat and filbert are the main types. Filberts are the full-bodied, oval-sectioned brushes that come to a point. Try a few of each before buying the whole range. Sable and synthetic hair brushes are all useful to oil painters, especially those who choose to work with colours of a more liquid consistency.

Kolinsky is the name given to sables of the highest quality. Another type called 'mongoose' is useful because these have the softness of sable and the springiness of

Hoghair brushes hold paint well and have plenty of 'spring'. Brushes for oil painting tend to be long-handled, which helps with their balance and also allows you to paint at a distance from the canvas. Flat brushes have long bristles and a flat cross-section, brights are similarly shaped with shorter bristles, rounds have a round cross-section, a filbert resembles a flat, but has tapering bristles, a fan is mop shaped.

Sable or mixed sable and synthetic hair brushes give a smoother look to the paint you apply than hoghair. They are also useful when you want to work in more detail. The best-quality sables are expensive but, if well cared for, will last a lifetime. Buy a small one for detail and a larger one for more general use.

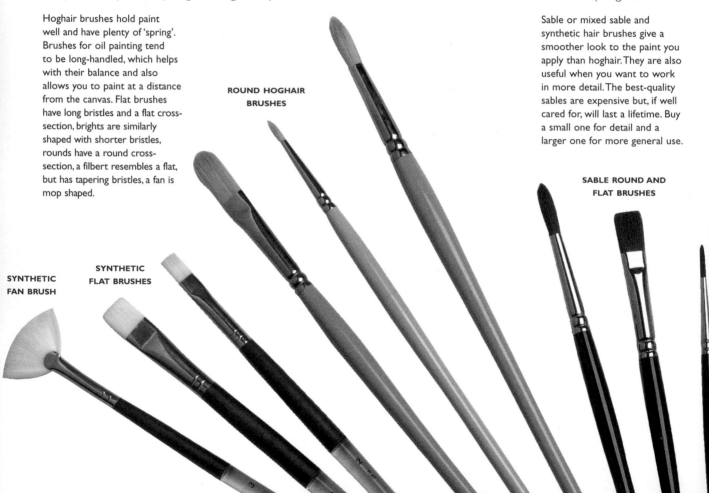

ROUND HOGHAIR BRUSHES

SABLE ROUND AND FLAT BRUSHES

SYNTHETIC FLAT BRUSHES

SYNTHETIC FAN BRUSH

ANATOMY OF A BRUSH

HAIRS
Many kinds of animal hair have been used to make brushes, the best of which is sable. A wide variety of synthetic fibres is also available, which now compare well with sable hairs.

FERRULE
The ferrule is the metal tube that holds the hair and attaches them to the handle. Avoid brushes that have a seam or join on the ferrule – these don't grip the hairs or wood well.

HANDLE
Handles are often made from wood that has been varnished to make it watertight. The brush handle is usually widest at the ferrule, the point at which you usually hold the brush.

HOGHAIR ROUND AND FLAT BRUSHES

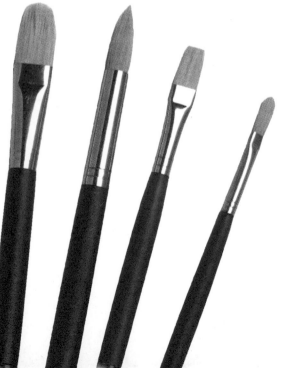

LOOKING AFTER YOUR BRUSHES

Natural bristle brushes, especially in the larger sizes, are expensive. Good brush-cleaning habits will preserve a brush's useful life. The hairs in these brushes contain oils that soak up paint and help to apply it to your support and move it around. If you use too harsh a cleaner for your brushes, you risk stripping the bristles of these natural oils and weakening the fibres.

You can use water and a mild soap that does not contain a degreaser, but the best cleaner is probably an artist's brush cleaner. Check the label that it is suitable for cleaning brushes that have been used for oil paints. These cleaners get the paint off the bristles without stripping them of their natural oils. After wiping or scraping as much excess paint as possible from the bristles, wash in cleaner until all traces of paint have been removed. Reshape the bristles between finger and thumb and stand the brush upright, on its handle, to air dry.

hoghairs. There are also synthetic brushes that closely match these qualities, usually at a fraction of the price. Very long-haired brushes in sable, called riggers, are used for drawing out fine lines.

It is useful to include a few decorators' brushes up to about 75 mm (3 in) wide for priming and tinting backgrounds. Of the many technical brushes that exist for the subtle blending of paint, the fan brush in hog, sable and synthetic and the 'badger' blender are the most useful. Buy a few that take your fancy and practise with them until you understand their qualities and what they can be used for.

Palette knives are useful for mixing paint and for cleaning the palette, in addition to applying paint. The trowel-shaped models are lightweight and flexible. The edge of the knife should be smooth to lift paint and apply it to your painting surface.

A medium helps you to control the flow of your paint, by diluting it to the consistency you want to work with. When you start out, turpentine may be all you need; as you become more accomplished, you may wish to experiment with some oils.

palette knives

Oil paint can be spread or manipulated using knives or spatulas, in metal or wood. A whole range of knives shaped like miniature trowels can be used to develop a style in which the whole picture is painted without brushes. The combined use of brushes, with palette knives being used to add emphasis of solid colour, is very effective in achieving dramatic results. Knives were most famously used by Gustave Courbet (1819–77) who is credited with the development of the trowel-shaped blade and offset handle, which gives greater ease of paint handling.

mediums

Liquids used to make oil paints flow are of three kinds: oils, diluents (sometimes called essences) and resins. In the oil paint that is sold in tubes, the pigments are finely ground

and either poppy or linseed oil is added. Many oils were used in the past, especially nut oils, commonly walnut oil. All of these are known as drying oils and they make the paint flow and respond to brush marks. They dry slowly and become part of the chemical makeup of the paint. Using too much oil can cause oil paint to darken. Stand oil, a modified linseed oil sold under that name, lessens the darkening process.

Diluents or essences are liquids used to thin oil paint which evaporate during the drying process. Turpentine is the most widely used diluent and, since most tube paints contain enough oil, simply adding turpentine to thin the paint is an excellent way of working. White spirit is a useful substitute for turpentine for cleaning brushes, wiping away paint and cleaning palettes, but if used as a diluent in the actual painting it will break down and weaken the paint film. Petrol can also be used and has the advantage of evaporating from the paint surface quickly. The petrol used for cigarette lighters is free of additives, but is of course highly flammable.

Resins have been used in many kinds of recipes for painting media and a glance at the shelves of any art materials store will show a variety of these. Read the small print if you wish to try them. The principle resins can be dissolved in turpentine but copal is a hard resin and, once dry, cannot be easily softened. Mastic and dammar are softer varnishes, sometimes added to turpentine to make a painting medium. Each have their own qualities and are delightful to paint with, but the most common use of these resins is as picture varnishes. They protect the finished work and make it easier to clean. Dammar used as a varnish gives a high gloss to prints and drawings. Many synthetic varnishes are also available.

A smooth flat surface is necessary for laying out and mixing your paints. An artist's palette in wood is one of the most common types and the thumbhole is useful, especially if you stand to work. You could also use plastic or glass, or a palette from a tear-off pad.

palettes

Medium-sized rectangular palettes with a thumb hole are the most practical. They are sold in wood and obviously the reddish colour will affect the way you see your colours when you are mixing them on the palette. The wood colour matched the tinted canvases used in the past but is not helpful if you work on a white canvas. A good alternative is a white plastic palette of the same size. If you have a painting room, a sheet of heavy glass laid on a table is ideal and you can put a sheet of coloured paper to match the tint of your canvas underneath it.

The large oval wooden palettes so popular in the 19th century are useful if you are standing to paint a large portrait, but can be quite heavy when fully loaded. Diego Velasquez (1559–1660), J. M. W. Turner (1775–1851), John Constable (1776–1837), Claude Monet (1840–1926), Auguste Renoir (1841–1919) and James McNeill Whistler (1834–1903) and others, seem to have preferred small rectangular palettes. Pads of tear-off paper palettes work very well and save the daily task of cleaning your palette. If economy is a consideration, use a glossy magazine to mix on and tear off each page when it is covered with paint.

easels

With oil painting much of the work must be done standing, especially if you are working on a large piece or a portrait. The work must be secured so that it does not wobble or shake. The classic studio easel has a ratchet mechanism, a tilting frame with winding handles and locking castors so that it can be wheeled around the studio, but for most of us such elaborate pieces of furniture are unnecessary, although they certainly look impressive in the studio.

More usual and essential for serious work is the radial easel, which can cope with pictures up to 1m (3ft) square. A tripod sketching easel is adequate for most small pictures. The metal ones are more stable owing to their extra weight and rigidity. Camera tripods with a drawing board bolted to the camera plate are a good alternative. A desktop easel is useful if you prefer to sit at a table to paint and are working only on small to medium pieces. If you have a painting room you can simply nail unstretched canvases to the wall, as Pierre Bonnard (1867–1947) did, sometimes leaving them there for years.

When choosing an easel, you need to consider its suitability for the type of painting you will be doing and the space you have available. Easels can be expensive but should last a lifetime. Make sure the one you choose is sturdy, easy to use and adjustable. If space is an issue, you may prefer a folding model and if you wlll be working mainly on small pieces, a tabletop easel may be adequate for your needs.

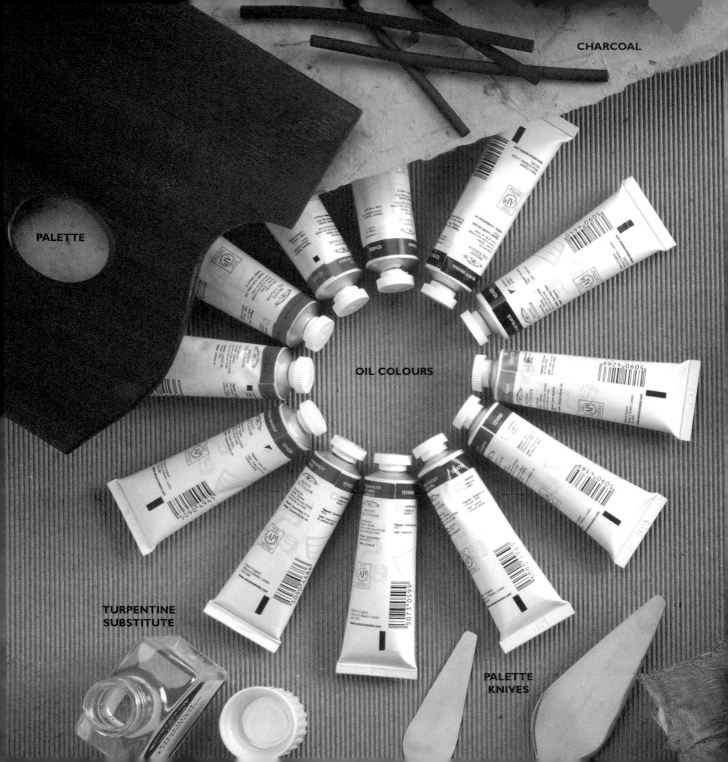

CHARCOAL

PALETTE

OIL COLOURS

TURPENTINE
SUBSTITUTE

PALETTE
KNIVES

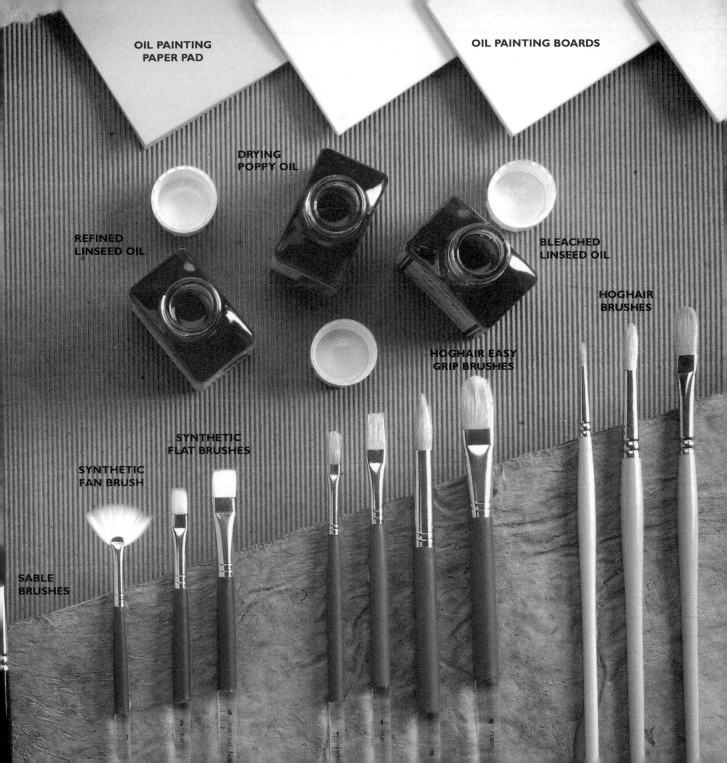

OIL PAINTING
PAPER PAD

OIL PAINTING BOARDS

DRYING
POPPY OIL

REFINED
LINSEED OIL

BLEACHED
LINSEED OIL

HOGHAIR
BRUSHES

HOGHAIR EASY
GRIP BRUSHES

SYNTHETIC
FLAT BRUSHES

SYNTHETIC
FAN BRUSH

SABLE
BRUSHES

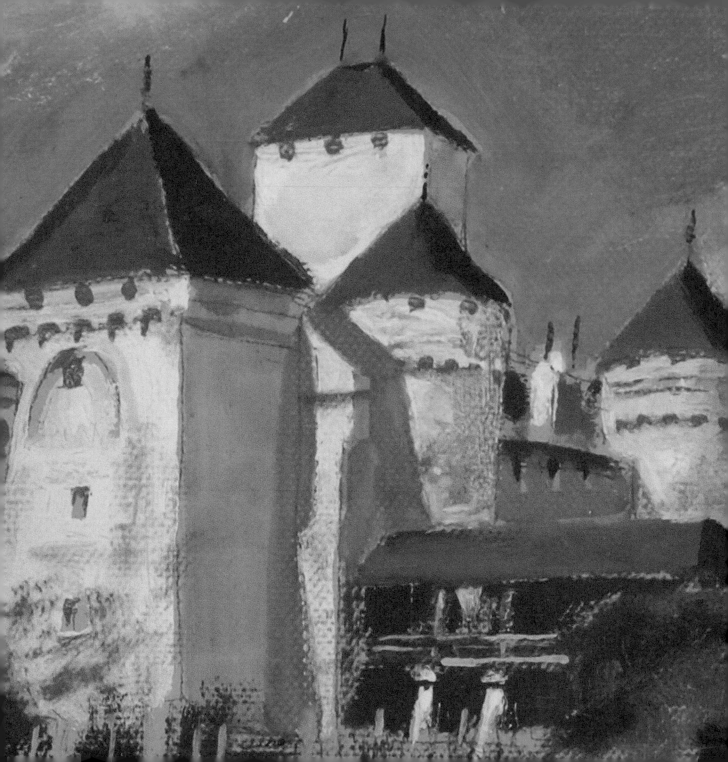

basic techniques

Before you can put brush to canvas, you need to know how and where to start. This section gives clear advice on the main oil painting techniques: preparing your canvas; controlling your brush; and mixing your colours. It also illustrates many of the innovative ways you can apply colour to canvas.

basic techniques

Oil painting is about getting paint onto your surface and moving it around. There are a few basic techniques that will help you to do this, but it is not necessary to master the technical aspects of oil painting in order to produce satisfying and successful works using oil colours. There is no substitute for making marks to teach you how much paint you need, how far it will move, how much medium you need to do what you intend, how to mix colours and how to exploit all the artistic possibilities of brushes and knives in your paintings. Putting paint onto a surface also shows you which are most appropriate to your style and the subjects you want to paint.

CONTROLLING THE MARKS YOU MAKE

How a brush handles depends on its shape and size and the combination of fibres that make up its bristles. You need to practise making marks, to get to know just what your brushes will, or will not,

applying paint to canvas

Generally you will be using two types of brushes to make your marks: hoghair and sable. When you use a hog brush, the shape of the brush and the degree of pressure you put on to bend the hairs are important. You can use the do. The types illustrated throughout this book may be all you need for your oil painting, but experiment with different combinations of brushes and surfaces. With practise, you will develop your own touch.

Hold a hog brush toward the tapering end of the handle, well back from the ferrule. Used flat on, you can create a feathery line of marks. Pressing harder makes blocks of colour. Hog brushes can also be used to scrub paint in. A fan brush smoothes paint out.

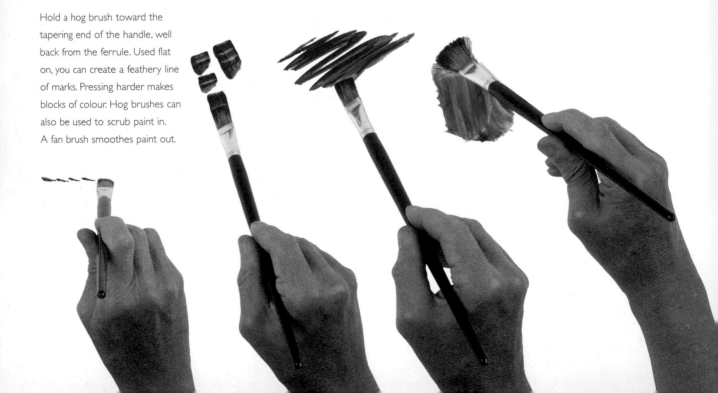

MIXING OIL COLOURS AND TONES

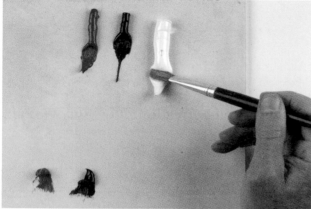

1 Lay out a strip of ultramarine and burnt sienna. Add a strip of white last. Take your brush and lift a piece of paint off the end of your first strip. Use a flat brush and 'bite' a bit off, then curl your brush to lift paint off. Repeat for your next colour and white using a clean brush for each.

2 Take your largest brush and mix the colours on the palette. Take up some more white and add it to the mix. If the mix is too stiff, add the minimum amount of turpentine or linseed oil to allow you to make finer strokes.

3 If you are going to graduate a colour on the canvas or board, add the white to it on the palette so that you have two or more tones of your main colour. Take up half the paint on the palette knife and move it onto another part of the palette.

4 Bite off a little more white and mix into the colour, so that you now have two tones of your mixed colour. If your colour is now too pale, take a palette knife and scrape some of your tone into the white. Keep the colours apart on the palette: they will be mixed on the canvas.

flat edge of the brush and practise manipulating it at different angles to create any marks from fine lines to thick blocks of colour and everything in between. You can also scrub in paint to make a texture or enhance the texture of the canvas. To apply small detail to a wet painting, use the point of a sable brush. A sable is also a drawing tool and can be used to make fine marks, either in your initial drawing or to sharpen detail as a painting progresses. Flattened out, the hairs of a sable brush will create broader sweeps of colour.

Palette knives are useful alongside or instead of brushes to get paint onto your canvas or board. As with brushes, you should spend time manipulating knives to see the effects you can achieve. The trowel-shaped models behave differently from those that are shaped more like knives. Use the blade, the edge of the blade and the tip and test out the types of marks you can create.

laying out a palette

How you lay out your palette depends on your individual preferences and the type of painting you do most. If your work is varied, then setting out all your colours in the same order each time you paint makes sense. You can use any smooth non-absorbent surface as a palette. A sheet of glass is ideal, as you can place a sheet of paper under it that is the same colour as your tinted ground. That way, your tones will be similar for the paint on your palette and on the canvas. Mixing colours on a mahogany palette for

SETTING OUT YOUR PALETTE

Artists have their own preferences, but a common and workable way to lay out a palette is to work from warm to cool, so start with the reds, then orange and the earth colours. The true yellows are next, then viridian and the blues and violets. Finally, add Payne's gray. Put your white to the right and separate from the other colours.

USING A PALETTE KNIFE

1 Take a medium sized palette knife. Put the lower edge of the knife on the palette. Draw paint toward yourself and rotate the knife. Apply to the surface by putting the lower edge down first. You will be able to feel how much paint there is.

2 Then gradually draw the knife across the canvas to 'spread' as much paint as you want. The lower edge of the knife is always doing the work. Go back to the palette to get more paint as you need it. Paint collects on the edge of the knife.

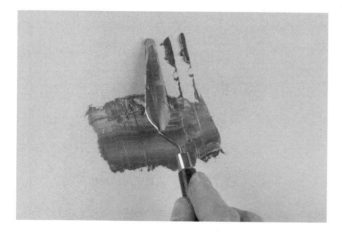

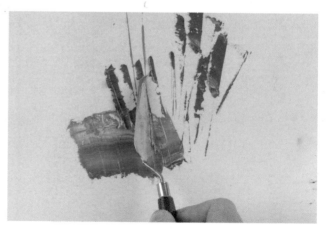

3 The important thing is not to cover whole blade with paint. Use the edge of the blade or the point of the knife. Now keep the knife at an acute angle so that when it touches, it will make a straight edge with a broken line and feather it out. This gives you fine lines.

4 By touching the edge of the knife into the paint, you will be able to create fine lines. You can also use a knife to scrape paint off the surface. Most of the time, the blade is at 45 degrees to the surface so that paint can slide out. The other edge does not touch the canvas at all.

PREPARING A SMOOTH GROUND

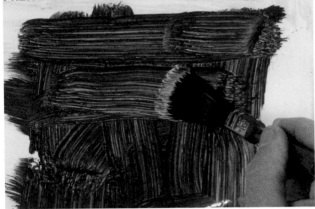

1 Mix up some ultramarine and burnt sienna. Use a brush sized for the canvas or board you are working on. Brush on the paint, working in all directions to start with. Smooth it off so you are starting with a fairly even colour.

2 If you find the colour is too dark for your intended background, wipe it off with your cloth, until it comes down to the lightness of tone that you want. Keep refolding your cloth so that you have a clean area to absorb colour with every sweep.

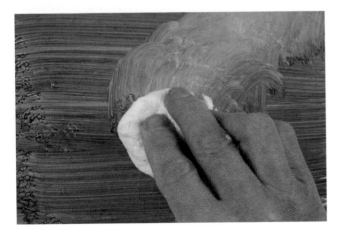

3 The cloth needs to be lint free, so an old cotton bedsheet or pillowcase is ideal. This is also absorbent to lift off colour. Continue to move your cloth across the canvas, taking out colour as you go, until you start to achieve the lightness of tone you want.

4 When the tone is as light as you intend for your painting, start to smooth your cloth across the canvas to make a background that is even in colour and texture. At this point, there is less colour on the canvas or board to move around.

PREPARING A TEXTURED GROUND

1 If you want a softly textured background, put your tint onto a smooth surface, because on a coarse-textured ground, any marks you make will disappear. Start by adding paint to the surface using a decorators' brush to create sweeps of colour.

2 Then take a large soft mop and start to tap the paint in a circular movement. This does not have to be even, you want the textured and uneven marks to show through. Stipple the paint across the whole board to create texture.

3 On a night or woodland scene, the texture and colour of the background may form a third of your painting. If your background colour is too dark, continue to stipple to take off some paint. Don't add white, as this would obscure the background colour.

4 It may require some practise until you know how hard to hit the canvas to get the strength of mark you need. Use different brushes for different textures. The longer you tap and wipe your brush, the more you will obscure the texture of the underlying canvas.

use on a white canvas makes it more difficult to compare like with like, although a palette with a thumbhole can be useful, especially if you stand at an easel to paint.

One traditional way is to start with white on the right up by the thumbhole. You need more white than any other colour because you use a lot and also once you have touched any other colour into your white, it's no longer white. For this reason, when you are colour mixing, use a separate brush for each colour and for white.

Arrange the colours starting with the warm colours, reds and oranges, through the yellows and earth colours, then blues on the left. Put black. if you use it and browns, on the extreme left. Another way is to put white in the middle and group cool colours on one side and warm on the other. Squeeze your colours from the tubes as long lines of paint, rather than as round blobs. This will let you take clean paint from the end of the line without sullying all the colour. If you are analytical about colours, you may decide to put out only those colours you intend to use in a particular picture.

preparing your surface

There is no need to prepare a canvas board in any way as long as you are happy to work on a white ground. If you are not, tint your ground as illustrated on pp. 36–37. Stretched canvases are sold sized, primed and ready for painting. Again, tint your background as appropriate. Other surfaces such as MDF, paper and card may need to be sized and then primed. You can buy oil primer from art stores or online. Most are suitable for applying to both metals and porous surfaces. These dry within 24 hours and can be tinted with oil colour before application so that you have a tinted ground when you are ready to start your painting.

BLENDING EXERCISE

1 Brush on a swirl of green. Then add some red on the other side of the apple. Apply a slightly darker red. At this stage, you are working with fairly solid blocks of colour only, with no mixing. The form is not yet recognisable.

2 Now mix some yellow into the green and add some patches of this colour into the darker green. Add some white to the red and add a patch of this down the left-hand side of the red block of colour, then add a swirl of colour onto the left of the form, now taking shape as an apple.

OK

3 Take a medium-sized brush and start to blend one colour into another, cleaning the brush on your rag as you go. The colours mix subtly into one another as the edges between the two blocks are softened and blurred.

4 Add more colour if you need to, using a small sable brush. You can also blend small areas using a sable blending brush. Because the paint is still wet, blending has to be done delicately. Just touch the brush to the paint. Wipe brush between strokes on your rag.

5 Take care that you do not move the colour around too much. To pull the apple from the background, add a blue shadow on the left of the apple, then add a slight shadow to the right. Work a bit of shadow into the apple and blend that.

6 Blend into the background using a scrubbing movement. Pull some paint down the right-hand side of the apple. Finally, use the blending brush to calm down around the area of shadow. This creates a recognisable apple anchored to a surface.

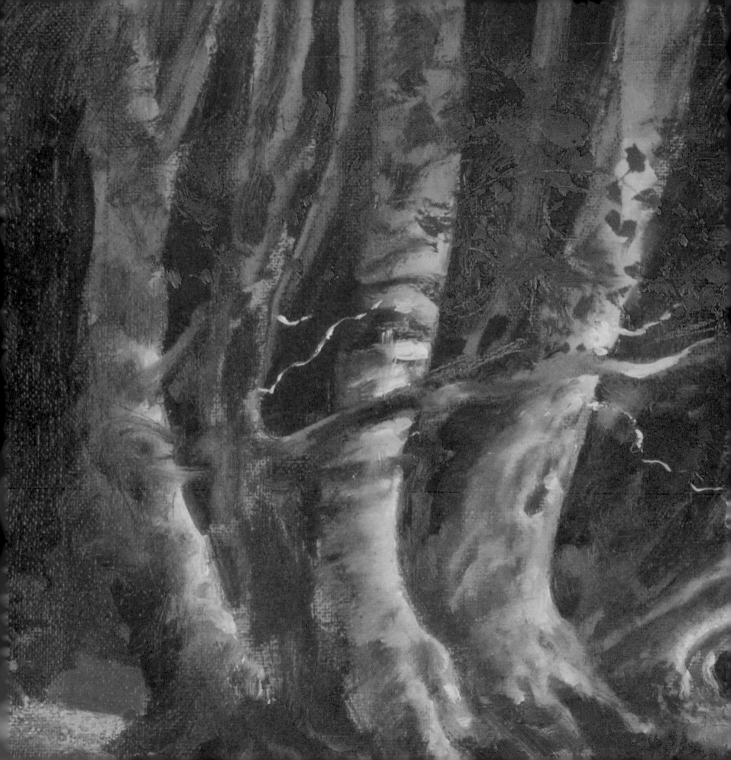

gallery

Oils are versatile and expressive: they can be used to create every style of painting from precise, detailed studies, to more impressionistic and abstract works. The styles of the works in the pages that follow and the vibrant use of colours may suggest ideas for works of your own in oil colours.

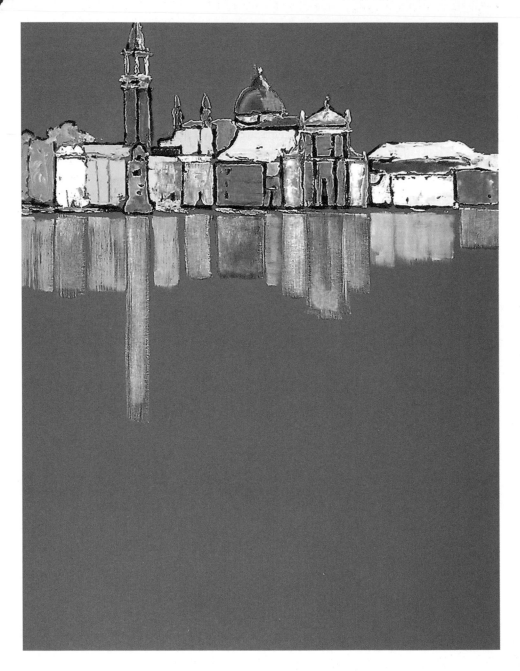

san giorgio II
930 x 830mm (36 x 32in)
mark leach

By analysing such a famous scene into simple flat areas and achieving a serene balance of colour and interlocking shapes, Mark Leach shows us the virtue of simplicity. This is an object lesson for aspiring painters.

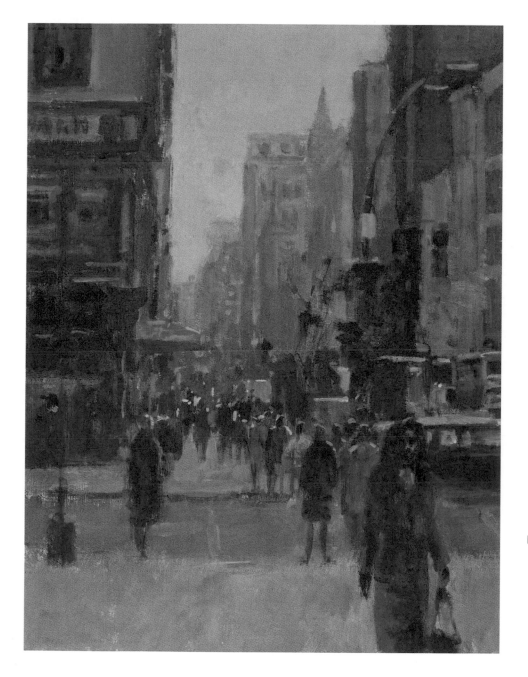

shoppers, new york
250 x 200mm (10 x 8in)
derek daniells

By contrast to the previous page, this painting uses many subtle greys to suggest the misty distance. Notice how the atmospheric scene is stabilised by the empty triangle of sidewalk in the foreground and the pale, flat sky.

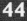

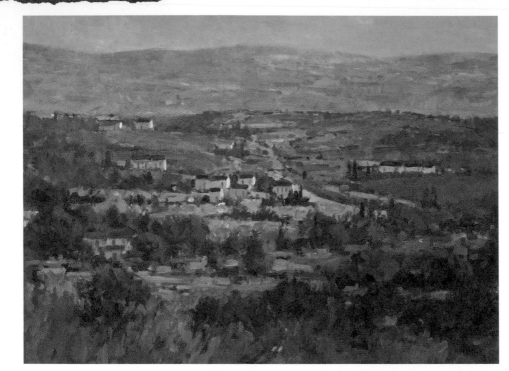

blue and green boats
600 x 500mm (24 x 20in)
moira huntly

By reducing the boats in
perspective to flat colour
patches, the artist has made
every area of the picture
work as part of an overall
pattern, while still gaining
a sense of light from the
contrast of the pale yellows
with the dominant blues.
This picture will repay
any amount of study.

tuscany
400 x 500mm (16 x 20in)
derek daniells

This broad landscape
demonstrates very well the
principle of aerial recession.
The farther hills become
paler and the colours get
closer to the violet blue
of the sky. By the repetition
of this blue in the scattered
buildings, the artist creates
a sensitive overall
balance of colour.

beach, falmouth
230 x 300mm (9 x 12in)
rima bray

A close harmony of
turquoise, lilac and blue
capture the seascape in soft,
flowing strokes without
elaboration. Learn from this
picture how to stop when
you have achieved your effect.

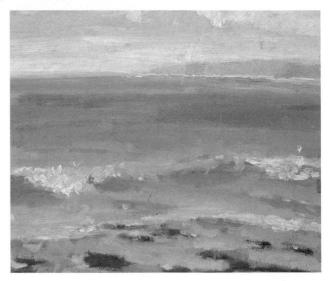

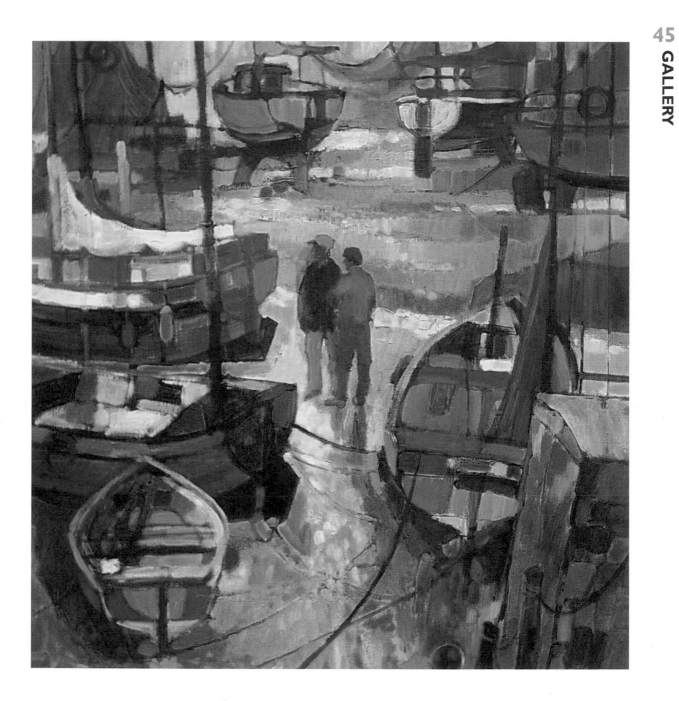

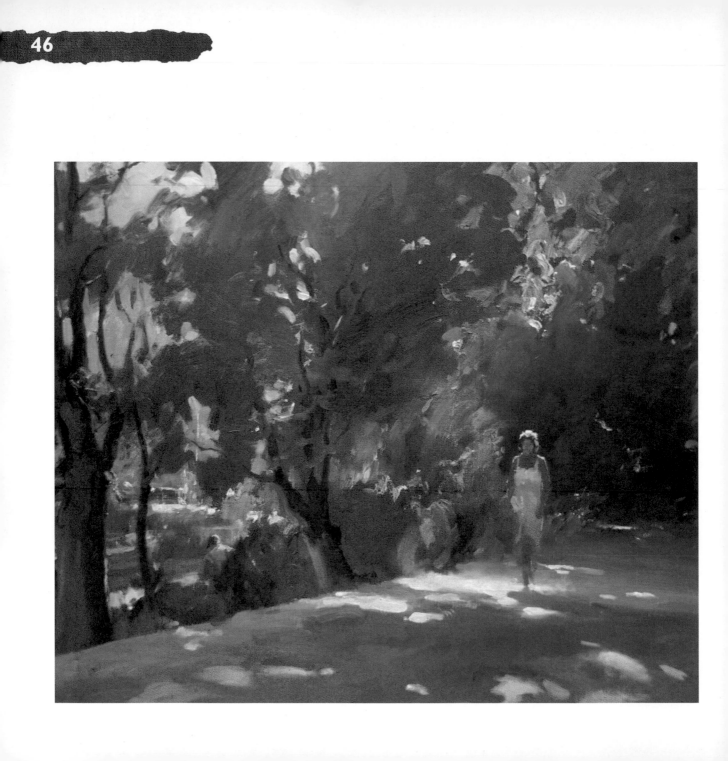

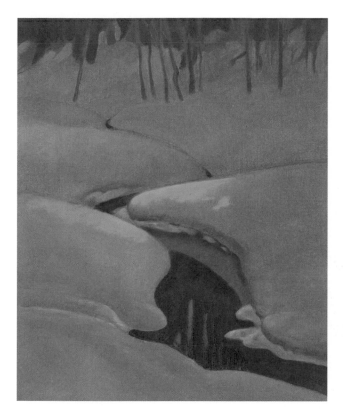

riverside walk, marble hill
500 x 750mm (20 x 30in)
trevor chamberlain

Free brushwork and careful colour choices create a superb scene. Note how much detail is suggested by the small touches on the boats and the small figure by the river. Study carefully the control of light, particularly on the main figure and the loaded brushstrokes in the branches above her.

winter sunlight
500 x 400mm (20 x 16in)
john barber

This painting attempts to catch the last glow of the setting sun by the contrast of one small patch of pink on the blue snow. The unseen sky, reflected in the stream completes an almost abstract approach to a natural scene.

hat shop
580 x 450mm (23 x 18in)
rachel bray

Shop interiors, particularly as here a milliner's shop, are a rich source of subject matter. A painter can choose from the variety of shapes and colours in the shopkeeper's arrangement or add their own. The opening door gives us an 'inside-outside' view of small scenes through the glass, although the strength of the door frame divides the composition and almost gives us two scenes on one canvas.

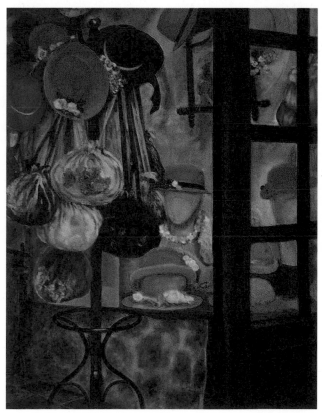

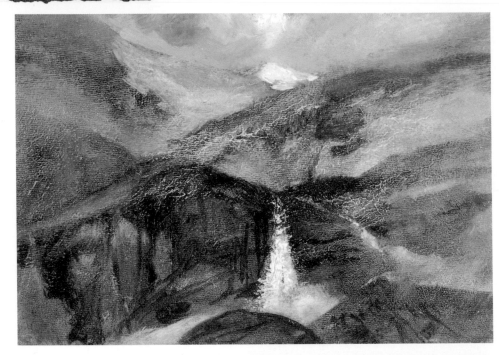

glacier in the bernese oberland
240 x 200mm (9¾ x 8in)
john barber

A brooding mountain scene, painted on the spot, is carried out almost in monochrome using a wrinkled texture for the underpainting as an important part of the finished effect. Much of the painting is sketched in thin washes, leaving the prepared rough surface to suggest the dirty ice on the glacier.

rocks at la lines
240 x 200mm (9¾ x 8in)
john barber

The fascinating subject of sunlight on sea and rocks has been interpreted by so many artists in all styles and schools of painting yet the possibilities for individual treatment are still endless. For this early sketch on cardboard, I sat on the rocks at La Linea in Spain close to the rock of Gibraltar.

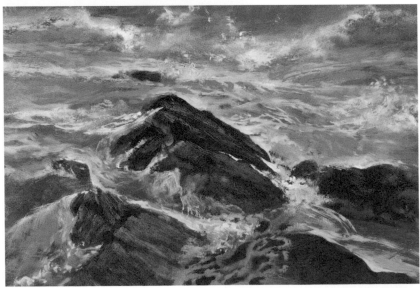

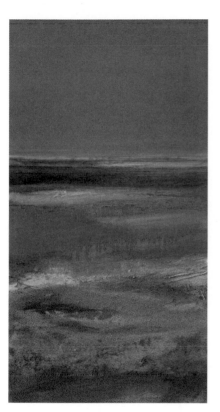

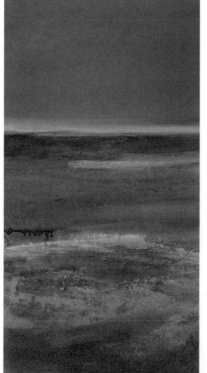

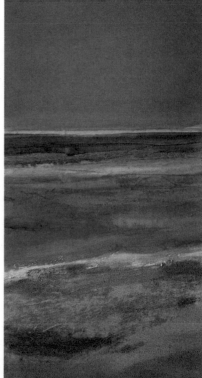

seascape triptych
each 400 x 200mm (16 x 8in)
joanne last

Making a series of paintings of a single scene has many decorative possibilities and small pictures like this, with the economic brushstrokes of a sketch, could be blown up large to make something like a folding screen, or hung together on the wall to suggest the view from a window.

pansies
550 x 750mm (22 x 30in)
rachel bray

Flowers can be the starting point for the most elaborate of compositions or, as here, simple flat pattern-making. By looking at the centre of each bloom, the problems of perspective are eliminated. Cutting off parts of some blossoms hints that the picture is a fragment of a larger whole.

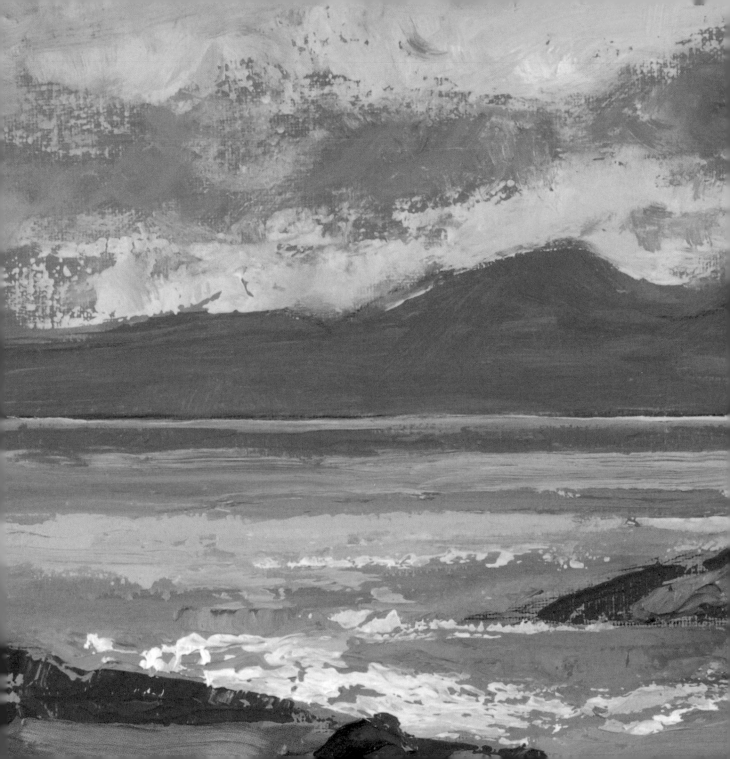

the projects

Being able to capture the essence of a scene or study is the skill all artists seek to master. These projects take you step-by-step through a wide range of different subjects, from still lifes to landscapes, using a range of techniques that will help you develop your talent as an artist in oil paints.

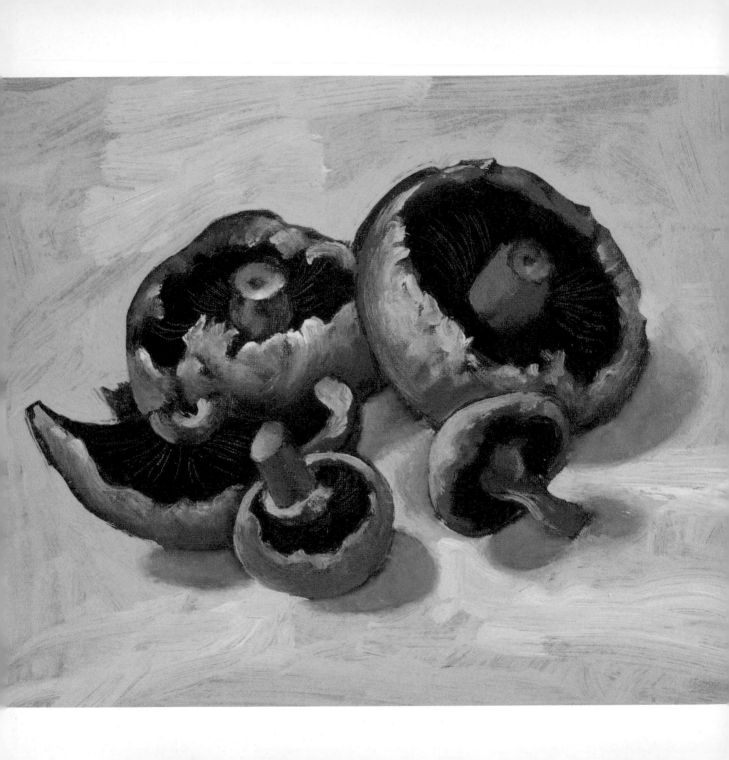

1

mushrooms still life

john barber
220 x 315mm (8½ x 12½ in)

This is a very limited palette still life, worked using only browns and greys, to demonstrate how far you can get into an oil painting without using white. This will help you to concentrate on the importance of the actual tone between dark and light without having to pay too much attention to the complications of colour mixing. When you have chosen your subject matter, bear in mind the fact that you will not be using white until well into the project when you start to tint your canvas. In this case a stippled effect has been left in the background tinting – this gives a sympathetic ground on which to build colour and to model the subject, a simple grouping of mushrooms.

TECHNIQUES FOR THE PROJECT

Using three tones

Working on a tinted ground

WHAT YOU WILL NEED

Tinted canvas
Conté crayon
Brushes: flat hoghairs nos 3, 5, 7 and 9
Turpentine
Rag

COLOUR MIXES

1 **Payne's gray**
3 **Burnt sienna**
4 **Yellow ochre**
12 **Ultramarine**

MAKING MARKS

This little study demonstrates just how much drawing and modelling can be done simply by using the slow-drying qualities of oil paint which allow the paint to be moved about for a long time. The instruments or tools you use to scratch through the paint will depend on your own interpretation of the texture you see in your subject matter. Knives and brushes are obvious tools to start with, then experiment. Georges Braque (1882–1963) used steel combs made for imitating wood grain in his Cubist paintings. Seeing this, Picasso (1881–1973) used his own hair comb to texture his paint. Keep an open mind and try whatever you feel like. You will be introduced to using a

simple version of this technique in step 2 of the project that follows, but work a few simple studies like the one here to build up your knowledge of how paint handles.

In the six photographs on these pages a small palette knife is used to make a wide variety of marks and it is perhaps wise to master the control of one tool before moving on to widen your range. You need not copy the technique drawing but can use your understanding of what is being done here to start you experimenting with other colours and other types of marks. If this little study had been started with red instead of green, the result might have suggested a flower rather than a vegetable.

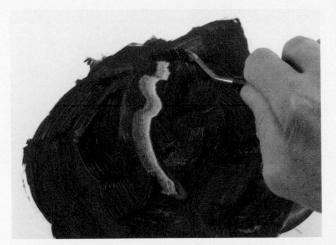

1 Mix up a colour on your palette using it as it comes from the tube. Don't dilute it as this exercise needs some thickness of paint. Spread it around with a hoghair brush to make a random shape. Leave any marks or texture.

2 Take a small trowel-shaped and flexible palette knife. Press the blade edge onto the paint and gradually push it away from you, increasing the pressure so that more paint is cleared at the end of the stroke. Wipe your knife clean each time.

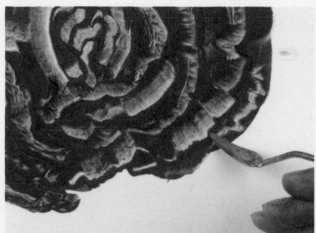

3 Now start in the middle of your patch and make some small concentric marks, working outward. Try to use the flexibility of the knife to make smaller marks by using less pressure. This time try bringing the blade toward you.

4 As you begin to get the feel of the knife working on the surface of your canvas or board, you will be able to make a greater variety of marks and control their shape. You will also begin to get a feel for the thickness of paint you prefer.

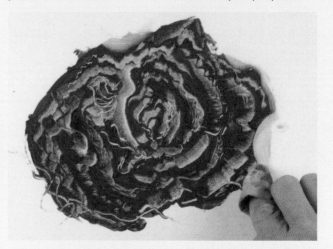

5 Draw in some fine crinkly lines using just the tip of the knife. Begin to really draw with your knife – you can use a brush handle to make marks if it is easier. The paint that is pushed away becomes an outline of the shape you have cleared.

6 Fill four patches of colour with marks, sometimes overlapping them. If you drag your knife outside the shape you will make lines onto the background. If some suggest a subject, keep them. If not, they can be wiped away with a rag.

mushrooms still life

Start by sketching in your drawing. In this case, a conté crayon is used: this stays on the canvas for longer into the painting process than charcoal would. Don't over-complicate the arrangement of the still life. With a still life, you are completely in charge of your subject.

DRAWING TIP

When marking out your drawing on untinted canvas use charcoal. On a tinted canvas, use white chalk on a dark background, or draw in your outlines using a dark oil colour. Oil colour marks will blend almost immediately into the painting when you start to add colour. This is the ideal solution when you are sure of your drawing.

Establish the dark areas of the composition using a mix of burnt sienna and Payne's gray. Mix the basic colour for the large areas, using a flat hoghair no. 7 brush. Use the edge of the shapes as your drawing line.

RIGHT Add colour to the darkest parts of the composition, the insides of the mushrooms. Then scratch through the paint, using the end of the brush handle, to reveal some of the tinted canvas, but don't overdo this.

STEP 1

STEP 2

The next thing to do is mix up a slightly more grey tone for the body of the mushrooms. Mix some ultramarine into your colour mix and thin to the consistency of a watercolour wash. This allows you to get some modelling on the mushrooms right. When you introduce white, the modelling will become more delicate. If you use too much paint, dab it off using your rag.

USING BRUSHMARKS

Sometimes the shape that your brush makes is attractive in itself and can be left in your painting as it is to contribute to your finished work. Remember that with a still life, you do not have to slavishly copy what you see in front of you. Modify the lines of your composition as your work progresses.

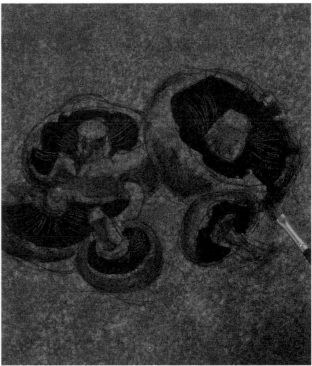

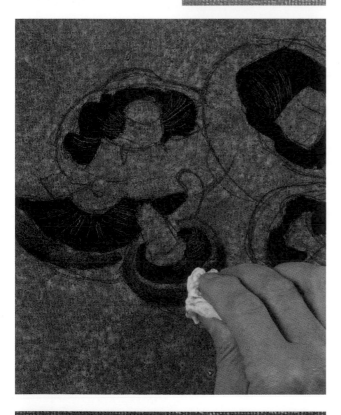

Continue to add this slightly more grey colour wash to the lighter areas of the mushrooms to build up the modelling.

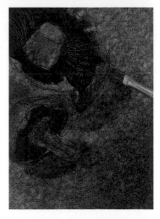

RIGHT Now look carefully at your composition and plan out the shapes of the shadows. This is easier to do while you are still working in monochrome.

STEP 3 ▶▶

STEP 4 ▶▶

mushrooms still life

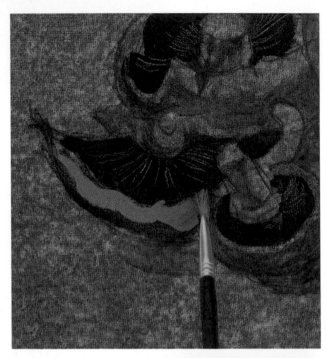

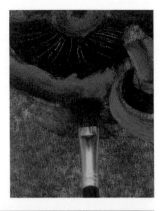

RIGHT Continue to create areas of shadow, where they fall around the mushrooms.

Mix the tints for the body of the mushrooms using white, yellow ochre and a touch of burnt sienna to warm it. Add a little ultramarine to one area of this paint mix so that you have a warm grey and a cool grey on the palette. Use the power of the white paint to lift the painting away from the tinted background.

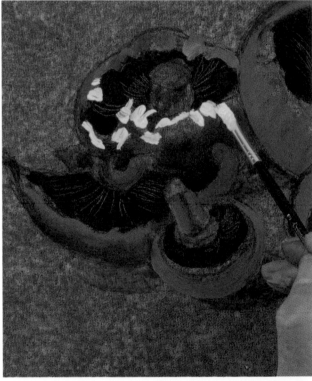

Add a light scumble to the dark areas of shadow. The shadow should be transparent.

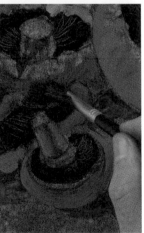

RIGHT Although you are putting on pure bluey-grey here, this will be modified by the colour of the tinted canvas. The background colour of the canvas will play an important part in this composition.

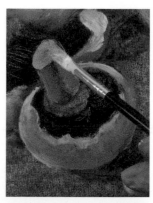

RIGHT For the bottom of the stem add burnt sienna to your lightest colour mix. This warms the colour, making it ideal for this earthy area of mushroom.

Add this same colour mix to other areas of stem. Work around all the cut stems, adding this colour mix to these areas. Blend with your finger, then work some dark accents to the underside of the mushroom using burnt sienna.

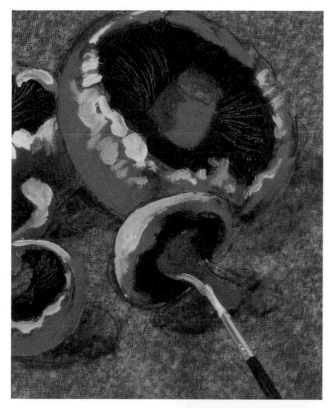

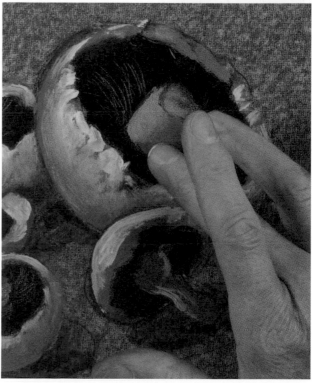

Work around the lightest areas of the mushrooms, that is, their edges. Using the white-tinted paint starts to lift the composition from the canvas.

TRICK OF THE TRADE

When blending your light patches of paint into the middle tone, use a clean brush and wipe it on a clean rag between each stroke. This will avoid lowering the tone of your lights. If the paint does not blend easily add a little clean turpentine to your brush and use this to help.

STEP 7 ▶▶

STEP 8 ▶▶

1
mushrooms still life

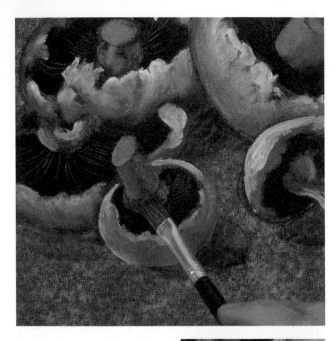

RIGHT Gently manipulate the paint to blend the white on the large mushroom. Using the light-toned mix which has a lot of yellow ochre in it, pick out the light areas.

It's important that the shape of the ends of the stems is oval, to show that they have been cut. On the largest mushroom the stem is brighter than the end, the reverse is true on the other mushrooms where the stems are brighter. Use your finger to blend the bottom of the stem into the dark flesh on the large mushroom.

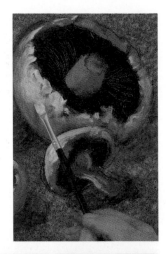

Use the flat brush to work some modelling on the stem. Moisten the brush with turpentine and drag it down the stalk.

RIGHT Having established the general tones of the composition, add more white to the mix to enable you to work the modelling on the body of the mushrooms. Adding colour to the canvas looks very dramatic but the colour will be blended. The edges of the mushrooms, where they curl over, are the lightest areas and there is a light 'collar' around the base of the stems. Add the lightest areas all over the painting first.

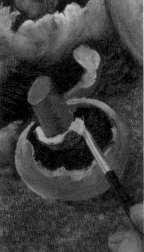

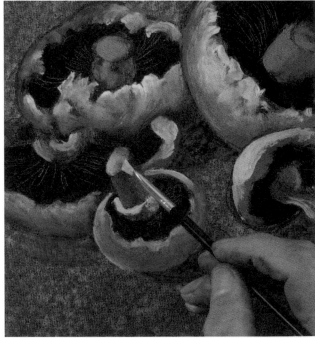

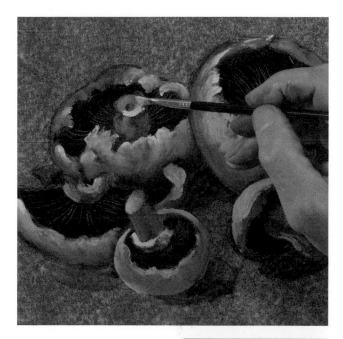

RIGHT There is now enough modelling on the mushrooms, so mix colour for the background. Add more ultramarine to the mix to cool it down. Mix plenty of colour so that you have enough (you don't want to have to mix more to match). The tinted canvas will not show through the background: the only areas of tinted canvas will be in the mushrooms, starting at the top.

Use plenty of turpentine in the mix to ease the flow of the paint around the mushrooms. Butt the background up to the mushrooms.

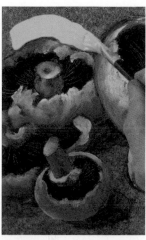

Now that most of the composition is finished, start to add some highlights, modelling on the stem of the mushroom in the foreground using your lightest colour mix. Now start to add some detail, showing that there is a pit in the middle of the stem. Knock this back to keep the subtlety of shading. Add modelling around the hole in the stem, but keep this subtle.

RIGHT If you start to get 'hot' spots, blend them back into the painting. Bring some warm subtle colour into the large mushroom.

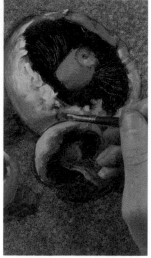

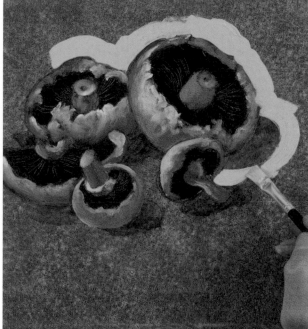

STEP 11 ▶▶

STEP 12 ▶▶

mushrooms still life

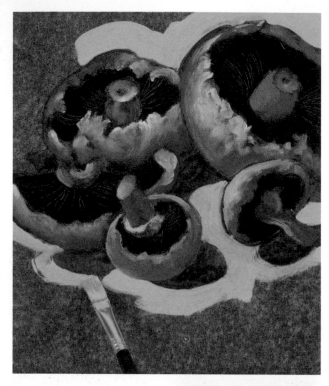

At this point, there is some visual confusion between the shapes of the mushrooms and the shadows. The shadows may need to be made cooler, lighter and less opaque. It is always best to keep white out of your shadows. Keep the shadows as transparent as you can: don't let them become opaque. At the same time as you are lightening the shadows, soften their edges by dragging them into the background colour.

TIDYING EDGES

When you apply your background colour, you can use the edge of your flat brush as your drawing tool. This gives you a chance to 'tidy' the edges of the composition and slightly change, refine and redefine the shapes of the various elements in the painting.

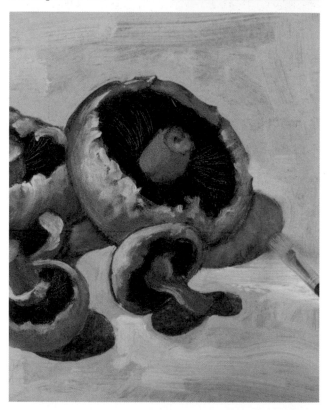

Work around the outlines of the shadows as you add colour to all areas of background. Go into the middle of the composition, using the corner of the brush, or switch to a smaller brush for detailed areas. Redraw shadows using your background colour. Continue to work around all the mushrooms.

RIGHT Don't blend out any brushmarks in the background. Once the mushrooms are outlined, start to scrub in broader areas of the background.

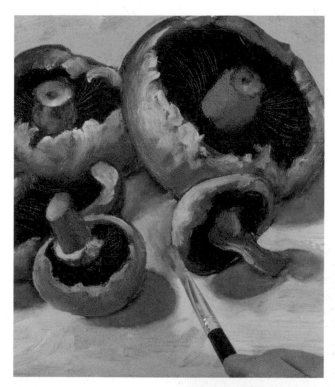

Finally, using the fine brush, add a highlight to the top of the mushroom in the foreground.

LOOKING AT LIGHTS

Look carefully at your still-life arrangement to determine where the lighter areas are. It may help to half close your eyes. Although you need a lot of white in the mix, avoid making your lightest colour too white and chalky. The colour should never approach pure white.

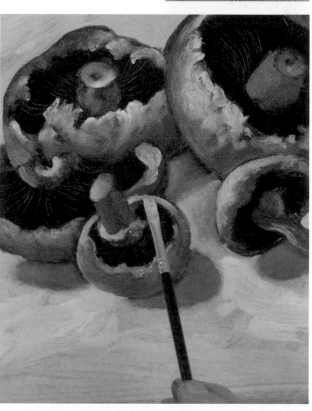

Draw the background out to a rectangle. Continue to work into the shadows. Now make the decision whether to create a shadow around the two mushrooms on the right. Change the tone here to make a shadow. Gradually moderate the shadows to make the painting 'work'.

RIGHT Soften the shadow of the mushroom in the top right and around the shadow of the mushroom on the bottom right.

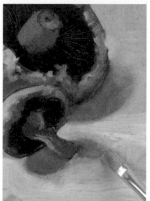

STEP 15

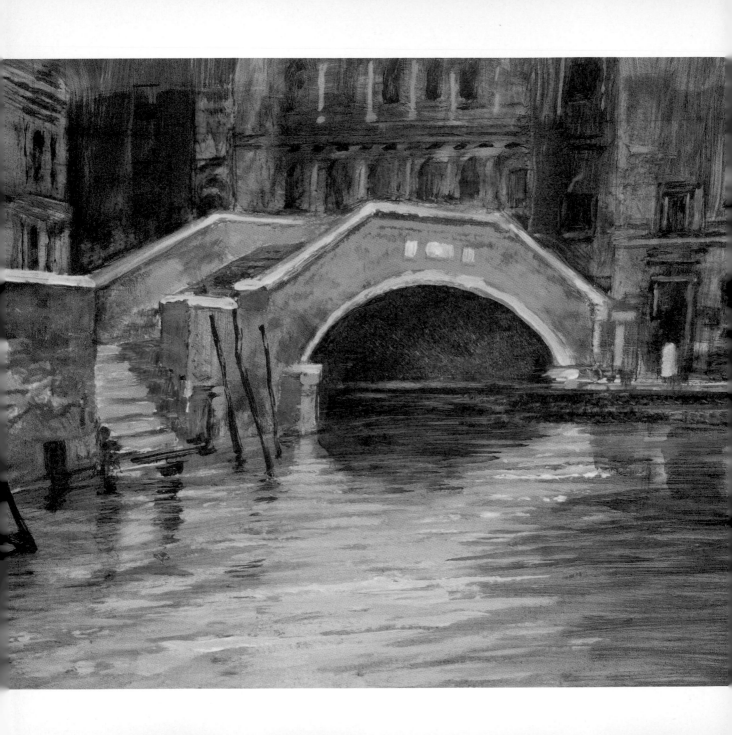

2

venetian bridge

john barber
280 x 360mm (11 x 14in)

A bridge is always a good subject for a painter. Venice is full of interesting subjects and, away from the grand vistas, the back canals with their crumbling brickwork, dark alleyways and constantly changing reflections offer countless starting points for artists to express their own reactions. In this project, the shapes are kept simple, the colour range narrow and the details of the buildings sketchy. Whether you are working from your sketchbook or from a photograph, draw your subject accurately, then relax into moving the paint around. Don't be afraid to experiment with bold marks – even wobbly and uncontrolled ones will keep your work lively and attractive.

TECHNIQUES FOR THE PROJECT

Working on a smooth surface

Leaving unblended textures

Scumbling and glazing over dry paint

WHAT YOU WILL NEED

Painting panel
Chalk or charcoal
Brushes: round sables nos 2, 7, 9 and 11; fan
Graphite pencil, 2B
Turpentine
Rag

COLOUR MIXES

1 Payne's gray
3 Burnt sienna
4 Yellow ochre
8 Cadmium red
9 Permanent rose
12 Ultramarine

USING TRANSPARENT WASHES

This simple study demonstrates how little you need to create believable shapes in your work. This tree is painted on a smooth, white panel, which is used to create the highlights – no white paint is used in the study. The paint is diluted to a thin consistency with turpentine. This has two effects: it makes the paint very easy to move around on the panel so that you can brush it out as you want; it also means that the marks of the bristles will remain on the panel, unless you choose to brush them out and these too contribute to the shape and texture of the finished study. Manipulating the brush allows you to create a variety of naturalistic marks of different thicknesses. The thin paint can be pushed around the board (and indeed wiped off it in whole or in part) to create shapes: you do not have to slavishly try to re-create a treetrunk and branches that would, in any case, probably not look real. In the project that follows, there is no attempt to create water, but the overall effect of the paint marks gives a realistic impression of the water in the canal. In the project, too, no white is added until the composition is clearly established and all the lights and darks have been worked out.

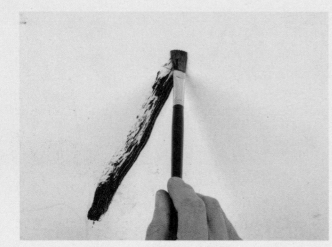

1 Start with pure burnt sienna, well diluted with plenty of turpentine. From your very first stroke of paint, the bristles in the brush create areas of light and dark, suggesting a gnarled tree trunk. Use the bristles flat to push the paint around.

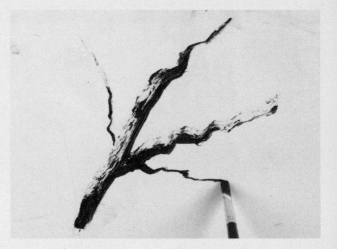

2 Smooth the pigment away to create tones for the two main branches. You are using only the tonal quality of the pigment and the colour of the background. Next. use the tips of the bristles to create a couple of finer branches.

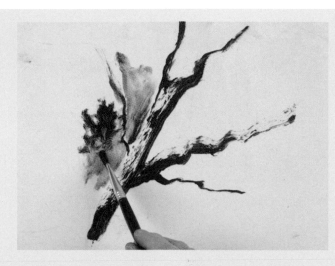

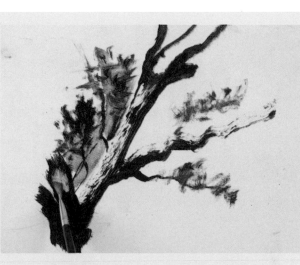

3 Work into what you have created, spreading the colour out. Use the smoothness of the surface and the transparency of the pigment to create your work. Push the colour about on the panel, using the marks you create as part of your drawing.

4 Wipe out a little of the pigment, to suggest a branch that has broken off. With a transparent mix like this one, you can wipe areas off as you wish: this is the great advantage of working with such well-diluted paint mixes.

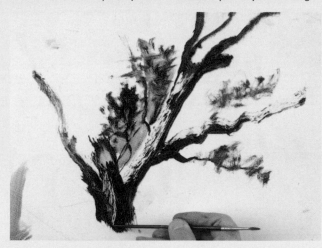

5 The paint itself is giving you textures, lights and shades. Use the end of the brush handle to scratch out pigment and get back to the colour of the ground. You could even go over this study again when it is dry, you can then build colour on.

6 You could use the paint from the tube, but diluting adds to the number of different textures you can achieve. Use the marks you create to model the tree. If a mark you make looks good and suggests part of a tree, keep it. If not, modify it.

Transfer your sketch to your panel, then sketch out the main lines of the composition using flat chalk or charcoal. You could also use watercolour, keeping the lines fairly fine. Draw in the main perspective lines.

COVER UP

In any painting on a white or cream ground, on which you are going to use white pigment for your lighter shades, such as oils or acrylics, the most important first thing to concentrate on is to cover all areas with paint so that you are not put off your painting by the whiteness of the panel, canvas, or board in the early stages.

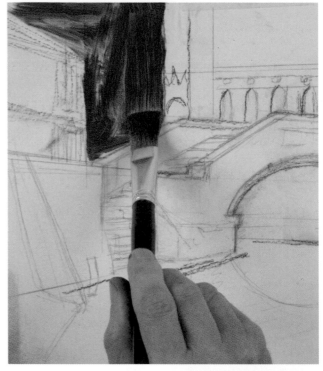

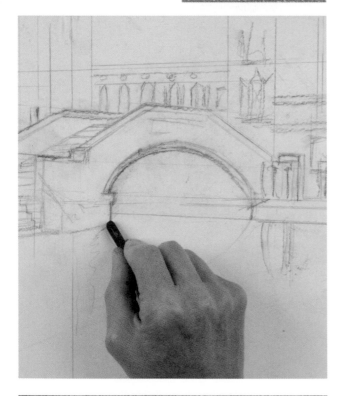

Start with a no. 11 brush and apply a wash of cadmium red over the right of the panel. Use fairly vigorous brushstrokes to cover the area. Modify the cadmium red with burnt sienna and Payne's gray and fill in the left-hand top corner.

RIGHT In these early stages, the painting is very like a watercolour in appearance. Work with the translucency of the mix, but scrub the paint in. The underdrawing is still visible here.

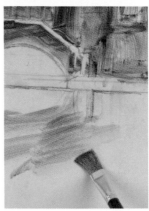

STEP 1 ▶▶

STEP 2 ▶▶

Continue to scrub in colour across all the areas of the panel. Start to add a yellow ochre, Payne's gray and cadmium red mix, over the cadmium red area you worked first to modify that colour. If it starts to look too colourful, wipe some colour off using your rag. Continue to add colour until there is no white panel showing. Then add some yellow ochre to the cappings on the bridge. Now the black chalk is starting to mix into the paint, modifying it a little.

LIGHT AND DARK

It is important to build up the darker areas, such as the shadows of the bridge, the reflections in the water and the windows in the buildings. These dark areas are going to be important in the finished painting and give you an indication, even in these early stages, of how your composition is shaping up.

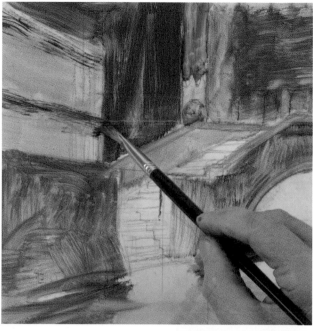

Now add Payne's gray for the water under the bridge. Then work the same colour around the base of the bridge. Neutralise some of the brighter colours by adding a mix of Payne's gray and burnt sienna to add a dark tone. Use this mix for the window on the left and on the right and to start to indicate areas of shadow. Continue to add cast shadows and dark windows.

RIGHT Work into the water using the same colour, then use it to bring the edge of the bridge into focus.

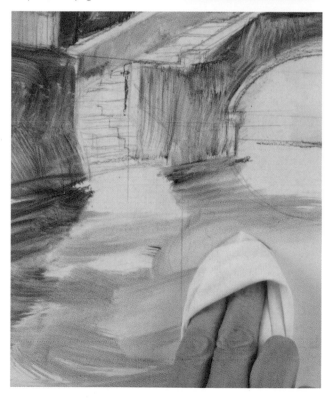

STEP 3 ▶▶

STEP 4 ▶▶

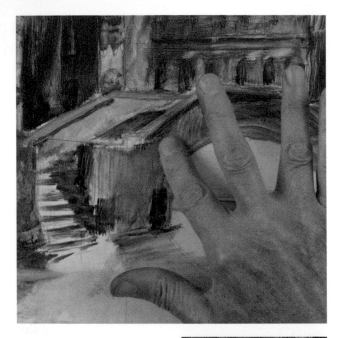

RIGHT There are dark reflections in this area of water but the cadmium red shows through to warm up the overall colour. The brushstrokes are still adding texture to the painting. Continue working into the water.

Mix a little burnt sienna into your shadow colour and use a no. 2 brush to create finer lines around the windows to bring them more closely into focus. Continue to add fine detail to the windows.

Now start to add texture to the brickwork on the left. You are still exploiting the flat texture of the panel to let your brushstrokes add texture. Use the same colour for the risers of the steps on the bridge. Blend the colour on the bridge with your finger.

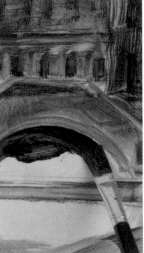

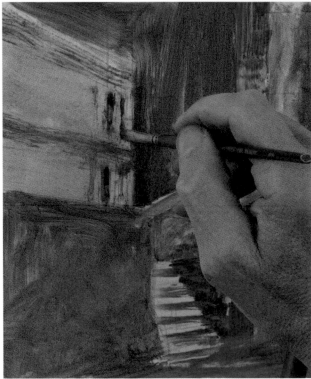

RIGHT Add some ultramarine to the Payne's gray to make a dark neutral colour for the shadows under the bridge. Switch to a no. 9 brush for these.

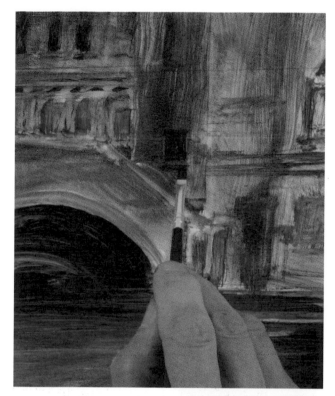

RIGHT Paint the pole coming down into the water on the left. This has a shadow in the water. Then add the poles on the other side of the bridge.

Now go back to your palette and add white to all the colours you have mixed. Using a no. 7 brush with the light ochre bridge colour, brighten the tones in the shadows on the top of the bridge. Only the façade of the bridge and the walls around it are in full light.

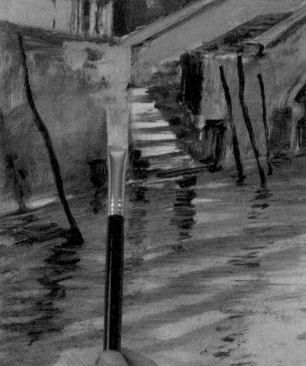

Move across to the windows in the centre and work their sills with greater precision. Continue to add fine lines to outline the windows in the centre. Add paint to the centre of the windows to darken them down. Blend this in using the no. 7 brush to give some texture and create the appearance of crumbling masonry. then work some darker tones into the window on the left.

WHITE BRUSHWORK

When you begin to add white to your colours, avoid the tendency to work with solid colour, instead dab it on. Using opaque colour in small strokes, rather than as a solid block of colour, means that the base colours and the brushstrokes of the underlying colours continue to show through into the finished painting.

STEP 7 ▶▶

STEP 8 ▶▶

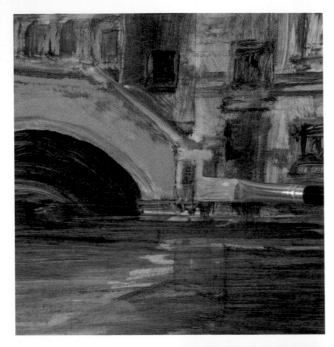

RIGHT Lighten your mix by adding a little more white to it, then work on the highlights on the cappings of the bridge.

Use the end of the brush handle to tidy the edges of the capping on the bridge. Add highlights to the base of the bridge on the right. Then work more highlight into the left of the bridge. Return to the steps and add a similar tone as you used for the bridge here. Use the same tone to strengthen the column.

Use the edge of the brush for the column on the right of the bridge which is catching the light. There are also a couple of light posts on the left.

RIGHT Add a little reflection at the foot of the bridge, then add some highlights to the cappings on the bridge.

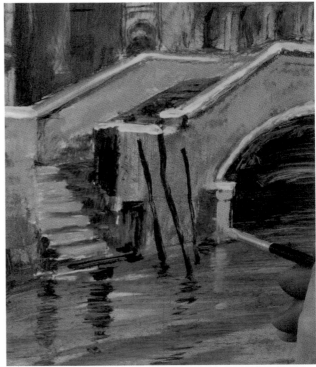

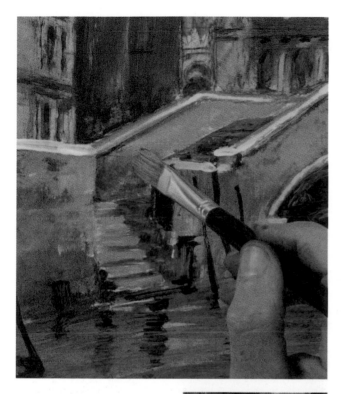

RIGHT Get some thick paint into the areas of water that are lightest. This also adds texture. Lighten the area of water on the right, where the dark reflection of the wall can be seen, then add more subtle whites to the water in the foreground.

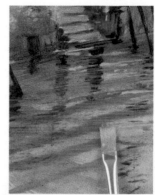

To add a touch of detail, using a pencil indicate three plaques on the bridge. The pencil marks will create shadows.

Work some lighter columns to the background buildings, using less white in the colour mix. Tone down the buildings where they meet the bridge and delineate this area using Payne's gray. Work some subtle paint marks to indicate crumbling masonry on the building on the left and then on the bridge.

RIGHT Using the edge of the brush, clean up the edge of the building to give it a bit of texture. Outline the bridge capping.

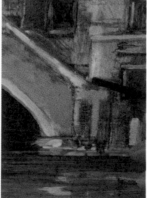

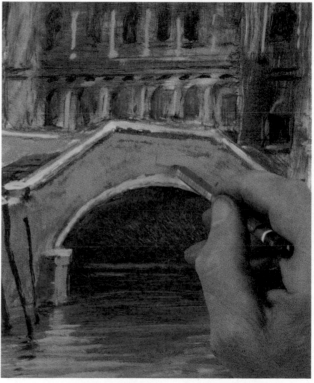

STEP 11 ▸▸

STEP 12 ▸▸

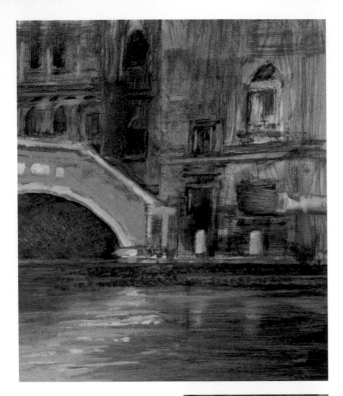

Rub a little burnt sienna and cadmium red into the water on the right, to echo the underlying red of the building on the right. Then return to the water under the bridge and use the stiffness of the brush to move the colour around. This allows some of the panel to show through and gives an even texture to this area of shadow. Stipple this very lightly so that you don't lift the colour that is there already.

REFLECTIONS

When painting water and reflections in water, take the brush backward and forward in parallel movements. Here and there, this will remove the existing paint. The colour in these areas is very subtle and there is a combination of paint and areas where the panel shows through.

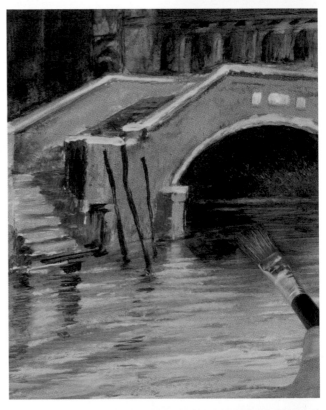

Paint the plaques using the bridge colour mix with more white added. Then work more darks into the windows on the right.

RIGHT Glaze over the buildings so that they start to play a less important part in the painting. Dilute Payne's gray with turpentine and wash colour onto the painting, as you would a wash in watercolour. Paint around the posts, leaving them in the light. Work on the buildings on the left, cleaning up around the edges.

GLAZING

Glazing means overpainting with certain colours, but not white, so that the underlying colours are modified but still show through. The colours have to be completely dry before you start to overpaint. In this painting, Payne's gray was used as a glaze to knock back the background buildings and make the bridge stand out.

LEFT The shadow on the bridge is now too dark, so add some burnt sienna and a little white to the Payne's gray to make it lighter.

For a final touch, with a small brush, run some colour down the posts, but avoid making these too light, then accent the corner of the bridge.

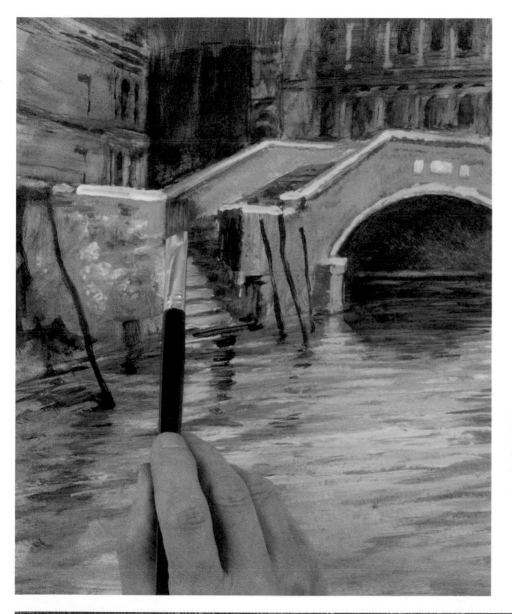

STEP 15

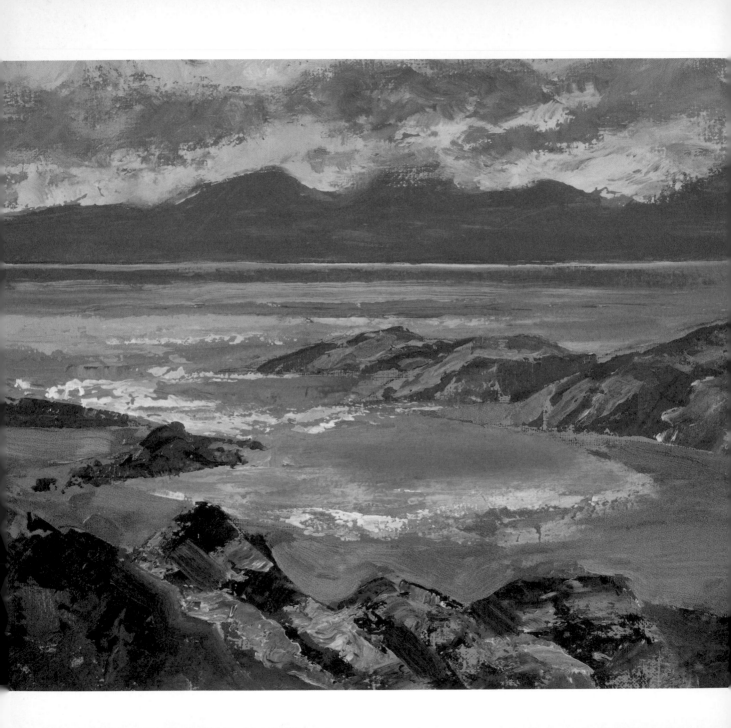

3

colonsay seascape

john barber

320 x 425mm (12½ x 16¾ in)

This seascape was painted from a fairly detailed black and white sketch, with notes on colour, made on the island of Colonsay in the Inner Hebrides to the north of Scotland. It is painted onto a canvas that has been tinted using a mix of Payne's gray and ultramarine. This tinted ground modifies all the colours applied to it. It can also be used as part of the painting, by scraping paint from the surface in certain areas. It demonstrates the flexibility of the palette knife and how an interesting composition can be built up using a fairly restricted palette. Brushes are used in places to modify some of the palette knife marks, without losing the sense of movement in them.

WHAT YOU WILL NEED

Medium-grained canvas
Black conté crayon
Brushes: flat hoghairs nos 6 and 8
Rag
Selection of palette knives
Linseed oil, turpentine

COLOUR MIXES

1 Payne's gray
3 Burnt sienna
4 Yellow ochre
10 Violet
11 Cobalt blue
12 Ultramarine

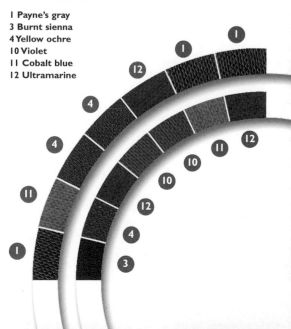

TECHNIQUES FOR THE PROJECT

Tinting a canvas

Using a palette knife

USING A PALETTE KNIFE

Palette knife painting can give a freshness and vigour to your marks and, contrary to what many amateur artists think, can be used with great precision. The key is to practise manipulating knives of all sizes to see what kinds of marks you can get, using the tip and edge of the blade, as well as its underside. When laying out the palette for palette knife painting, it's useful to lay out the colours in lines as they come from the tube, so that you can 'snip' a piece off the line easily, without dirtying other colours. The paint is used directly from the tube, with as little dilution as possible. Paint from the tube is about the right

consistency to spread in a fairly controlled manner. This little study is an ideal introduction to the project, suggesting forms for sea and cloud that can be used in your finished painting. As with any other type of oil painting. If you don't like a mark your knife has made, scrape it off and try again. Don't be too quick to remove a mark, however. As the project shows, a knife mark or spread of colour can suggest a form that you can work with. In the painting that follows, several of the cloud and wave forms are derived from 'accidental' shapes that suggested a way to proceed.

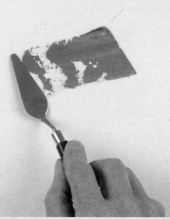

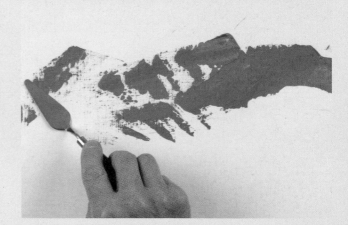

1 Mix up ultramarine and white. You don't have to 'wash' palette knives when you change colour. Simply wipe on a rag. Scrape the paint onto one edge of the underside of the palette knife, so that you know exactly where it is.

2 Put the knife on the canvas at 45 degrees and scrape across the canvas, gradually using all the paint. Move your wrist to change direction. Keep the blade at 45 degrees to the canvas and use the pressure of your index finger to manipulate the knife.

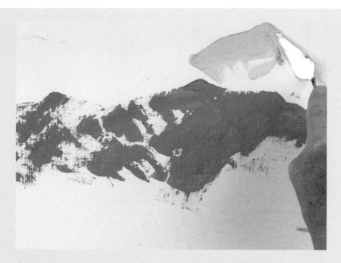

3 With the end of the knife you can manipulate the paint fairly precisely. Use the texture of the canvas to manipulate the paint further as you drag it across the canvas. Wipe the knife between strokes if you do not want accidental marks.

4 Use the edge of the knife as a drawing tool. When you want accuracy you need to lay the edge of the knife carefully on the surface of the canvas, to give you your straight lines. Lift the knife from the canvas with care to avoid smudging.

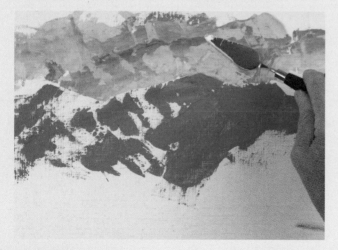

5 You can always take a brush to spread out the colour from the knife marks. Also, use the accidental shapes that the knife has given you in your painting. These will suggest forms and can be exploited to good effect in all sorts of subjects.

6 Using a smaller palette knife at 45 degrees, slide the blade down the canvas with only the edge touching. Hold the knife lightly to feel the drag on the knife. The combination of heavy handle and light blade allows easy manipulation of the knife.

Tint a canvas using a mix of Payne's gray, ultramarine and white to cover the white canvas. Sketch out the main lines of the composition using a conté crayon (this is essentially an oil pastel). Rule in the horizon with a straight edge. If you lose the horizon in a seascape, your sea will not be convincing. Then outline the edge of the mountains and the snaking line of the rocks curving around the little beach. This is one of the most important lines in establishing the composition.

PAINT ECONOMY

In palette knife painting, it's a good idea not to think about paint economy. If you run out of a colour, not only will it delay your painting, but you will also find that mixing more colour to the precise shade for colour matching can be difficult. Mix generous amounts of your main colours, so that you can work freely.

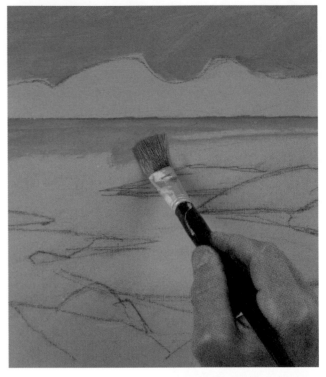

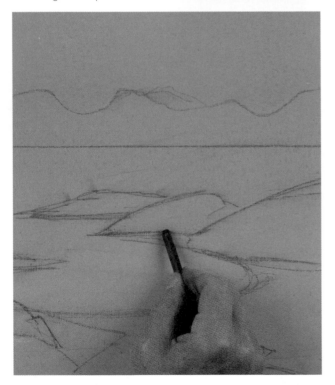

STEP 1 ▶▶

Start with brushwork to lay in some areas. Scumble on some base colour with a brush to give an outline of the general tones of the picture. Roughly brush in the sky with a blue-grey tone, mixed from Payne's gray and ultramarine and continue this into the sea.

RIGHT To your colour mix, add some cobalt blue and white. By using the paint fairly thinly, you can still see the colour of the tinted canvas showing through.

STEP 2 ▶▶

Now, still with a brush, put in some dark colour over the mountains. This is mixed from ultramarine, violet and a touch of Payne's gray. Establishing the main areas of colour and main tones of the painting with a brush means that you are less likely to be distracted when you start to apply paint using the palette knife.

SPEED DRYING

If you are working with heavy knife marks and thick paint, but still need your palette knife work to dry quickly, use decorator's white, rather than artist's flake white, as your white. Adding this to your colour mixes will speed drying time considerably.

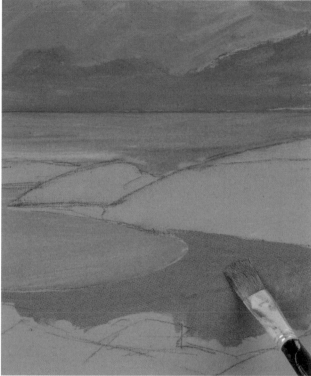

Use yellow ochre and violet for the beach. This is a fairly thin mix. Take a rag and wipe off some of the colour so that the grey-tinted background starts to show through again.

RIGHT Begin to lighten the sky using the palette knife. The colour here needs lots of white in it, but it also has yellow ochre and ultramarine mixed with it.

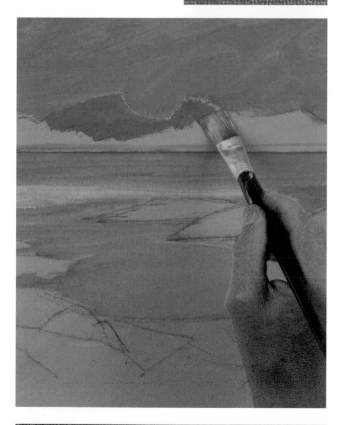

STEP 3

STEP 4

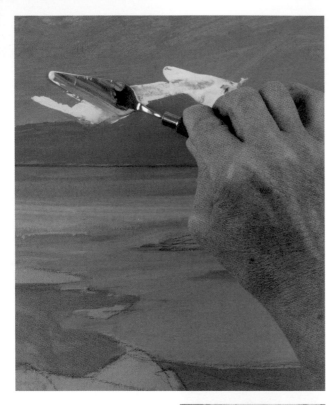

RIGHT Revert to the dry brush to smooth out the effect of the broken water.

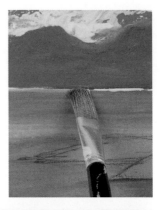

Now start to bring some of the darkness of the mountains into the sea. Using a palette knife with a slightly longer blade allows you to apply long, thin lines of paint.

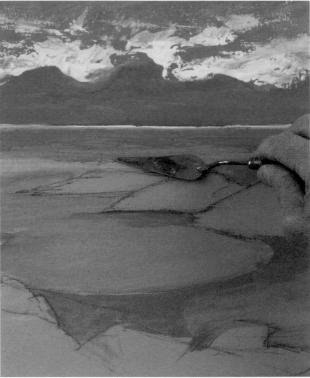

Once you have some paint on the canvas, use the heel of the knife to get the edge of the mountain. Continue working across the mountains.

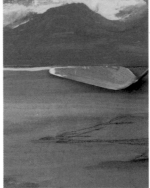

RIGHT Use the same colour mix as the sky to make the far light on the water. Using the edge of the knife, outline under the mountains, on the water. This reinforces the horizon.

STEP 5 ▶▶

STEP 6 ▶▶

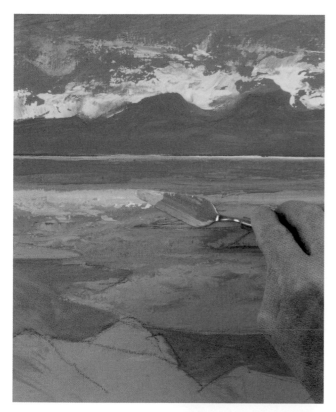

RIGHT Take a dry brush across this area so that it does not look like a breaking wave.

Create a sensation of breaking water on the left of the painting and indicate a swirl of water in the foreground. Once you have paint on the canvas, it is easy to move it around.

Add more ultramarine to the mix and continue to work the darker areas of sea. Then, mix in some cobalt blue and a tiny amount of yellow ochre to give a more greeny tinge to your colour and start to work on the lighter areas of water.

TRICK OF THE TRADE

You always have the option of brushing out marks that you have applied using a palette knife, but this may lose some of their vigour. If you do not want to lose the vigour of the palette knife marks, use the corner of a flat hoghair brush to manipulate the paint.

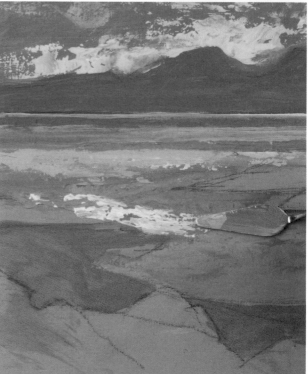

STEP 7 ▶▶

STEP 8 ▶▶

RIGHT Work on the rock in the foreground. This has a dramatic profile.

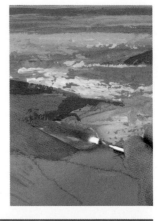

Use the same colour for the rock in the extreme foreground. Drag the colour onto the surface of the canvas to give a texture to the surface of the rock.

Bring some more light into the top of the sky so that it does not start to look too dark. Use a mix of ultramarine and white. Brush this out to manipulate it a little. Blur this area of mountain to create the illusion of a cloud.

RIGHT Now start working on the rocks, using a mix of Payne's gray and burnt sienna. Use this directly on the background tinted canvas. Make your movements follow the lines of the rocks. Apply colour and spread it out.

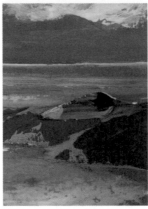

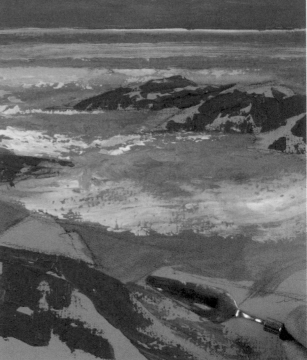

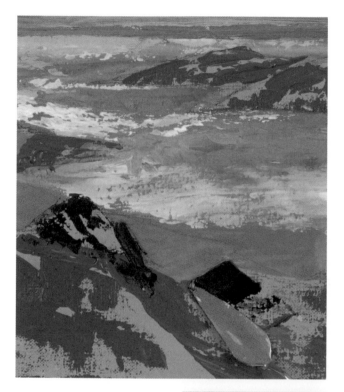

RIGHT Add some white to the mix to make the beach look more dramatic. The colour had become too strong.

Drag some of this colour mix into the water to create the illusion of sand under the water. Add some burnt sienna, Payne's gray and white to the beach colour mix and do some solid palette knife work on the tops of the rocks to create some modelling on them.

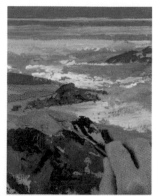

Again using a mix of Payne's gray and burnt sienna, but this time mixed to a darker tone, work on the rocks in the foreground.

RIGHT Work on lightening the whole of the beach. Use a smaller knife to enable you to manipulate the colour of the beach around the rocks. Use a mix of burnt sienna, Payne's gray and white. Work across the beach, outlining the rocks as you do so.

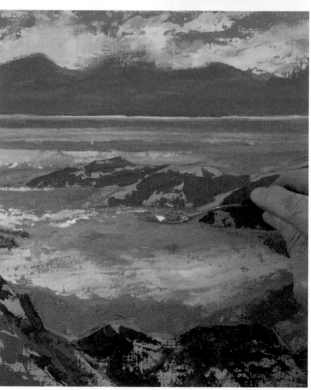

STEP 11 ▶▶

STEP 12 ▶▶

3
colonsay seascape

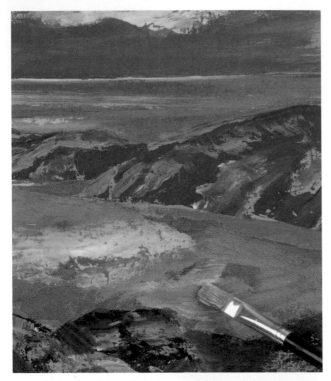

The sky needs softening, so use a brush for this. The marks made by the soft brush blur the edges of the clouds. The colour here is slightly warmer, a mix of violet and yellow ochre. This takes the harshness out of the clouds, which were starting to look too rocklike.

REMEMBER

The textures you get when you drag your colours onto the canvas are influenced by the texture of the canvas. If you use a coarse-grained canvas, you will start to lose the texture of the palette knife marks. On a smoother-grained canvas the knife marks will remain more apparent.

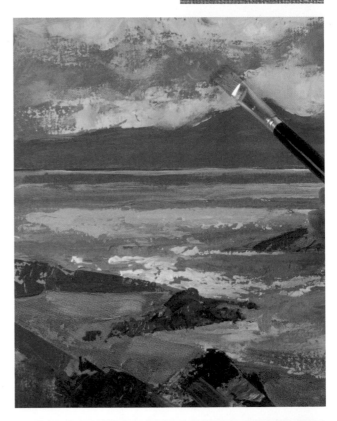

Use a brush to make adjustments to the shapes of the rocks, to make them less chaotic. Then work some lighter areas into the beach. Use a flat brush for this.

RIGHT Repeat this brushwork on the left of the painting and into the central area where the sea is flooding over the beach.

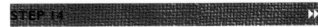

TRICK OF THE TRADE

When painting with a palette knife, use the paint as it comes from the tube. This will give a solid covering and you will feel the drag of the paint under your knife. If this feels too stiff, add a few drops only of linseed oil mixed in on the palette rather than diluting with turpentine.

LEFT Go back to the palette knife and start to sharpen areas of the water. This draws attention to where the edge of the water is.

Brush some more cobalt into the edge of the beach and sea, to give a more solid blue. Take a look at all the tones, then lighten the sea slightly to make the profile of the rocks more apparent.

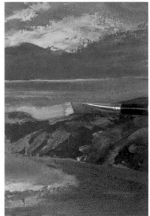

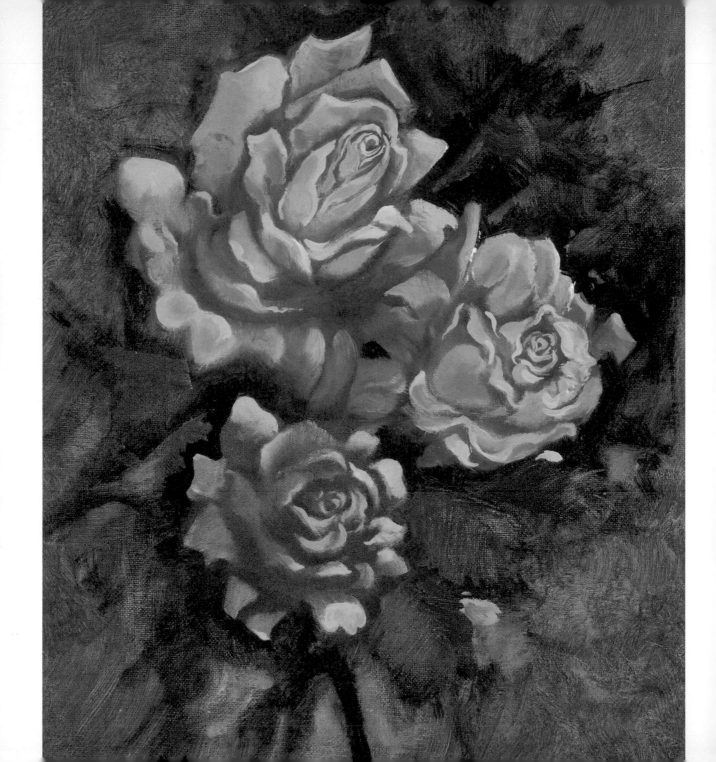

4
roses
john barber
400 x 290mm (15¾ x 11½in)

An arrangement of three flowers is the starting point for this project. Dark backgrounds are really helpful in enabling the power of white paint to effectively suggest the clear beauty of petals and leaves. Here, the study is of a group of roses, but any floral subject would benefit from the solid lights and easy blending that the medium of oils affords. Endless exciting possibilities of the medium can begin to suggest themselves to you as you work through the stages of this project, leading to the development of your own artistic tastes and preferences. In this study, the starting point was a photograph, but you could also cut or buy some blooms and arrange them to your liking.

TECHNIQUES FOR THE PROJECT

Working on a tinted ground

Achieving form using three tones of one colour

Blending

WHAT YOU WILL NEED

Tinted canvas
Black conté crayon
Brushes: round sables nos 2, 3 and 5; flat sable no. 4; flat hoghairs nos 2 and 8; fan
Linseed oil, turpentine
Rag

COLOUR MIXES

1 Payne's gray
2 Viridian
6 Cadmium yellow
9 Permanent rose

USING THREE TONES

This study demonstrates how you can build up a subject using three tones only: middle, dark and light, in that order. This 'recipe' for oil painting – that is, tinted ground; middle tones using the tinted ground unpainted in some areas, shadowed areas in a darker tone of the same colour and light created with white added in varying amounts – is the classic use of the medium. As you work through this little preparatory study and the stages of the project that follows, you should gain an understanding of the flexibility of this method of working and its importance in the realistic rendering of objects. You will also learn to look more closely at the subjects you are painting to note the

relationship between the different tones that you can see, which areas are the lightest and which are in deepest shadow and the often beautifully subtle differences that are apparent between the middle tones.

The canvas for this study was prepared using a mix of Payne's gray and white, but it appeared too dark for the delicate subject, so some of the paint was wiped out with a rag. The marks that are created when you work in this way can be incorporated into your paintings, as is the case in the project that follows, where the initial tinting of the canvas contributes to the lights and darks that are created in the finished work.

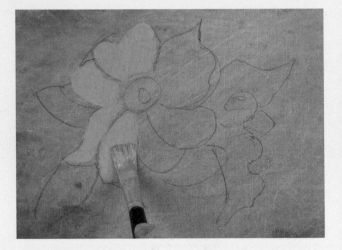

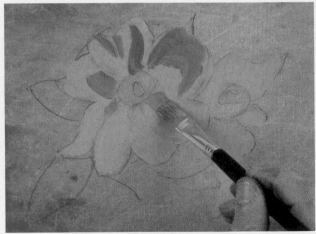

1 Use the middle tone to cover each area with flat colour. Use colour simply to block out the flat shapes, not worrying at this stage about modelling. If necessary blend the patches with a clean brush, which will help you to get rid of any remaining chalk marks.

2 Now cover the areas that are in shadow with your darker tone. The shadows are drawn as flat shapes, without any intentional blending. When looking at a flower, half close your eyes and note carefully where the shadows fall.

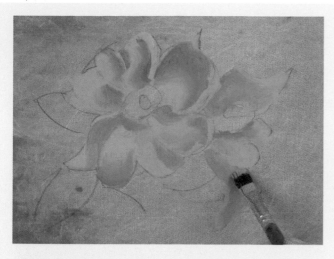

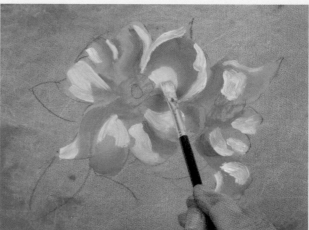

3 Start to blend the two tones with a softer brush. This needs to be done gently, since both the middle and dark tones are still wet. You are working with only wet paint and turpentine in this study. Leave the cast shadows so that they still have a crisp edge.

4 Use a small hog brush, no. 5 and add a great deal of white to the middle tone, to create the lighter tones. This needs accurate drawing of the shapes. Put the shapes of the lights on first and then start blending to get a sense of roundness into the petals.

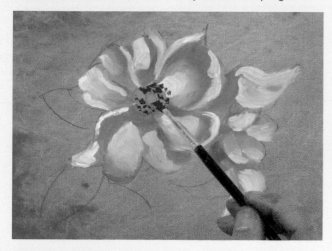

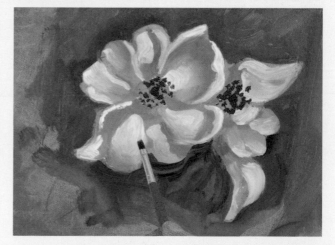

5 Add stamens to the centre of the flower, using pure cadmium yellow. Finish off by adding a touch of viridian to make a colourful flower painting. To make the petals appear stronger, turn now to the background, using Payne's gray and viridian.

6 If you pick up any of the colour of the flowers into the background, leave it, as this helps to harmonise the composition. Highlight the lightest areas. Blend with a softer no. 4 sable brush, wiping the brush on a rag between brushstrokes.

Begin by sketching the subject with a conté crayon. Start from the top and fill in the shapes of the petals. It is important at this stage not to lose the shapes of the petals. Leave a slight space between each petal, so that you can see your initial drawing later into the painting. Mix some permanent rose and white, but do not add so much white that you obliterate the background tone completely. Start to add colour using a no. 11 brush.

TINTED GROUNDS

You can deliberately tint a ground in an uneven way with a large brush. You will get brushstrokes showing through. If these marks look attractive, you can keep them and they will enhance the movement of the paint. Rubbing away some of the background starts to give you areas of light and shade, before you start on your painting.

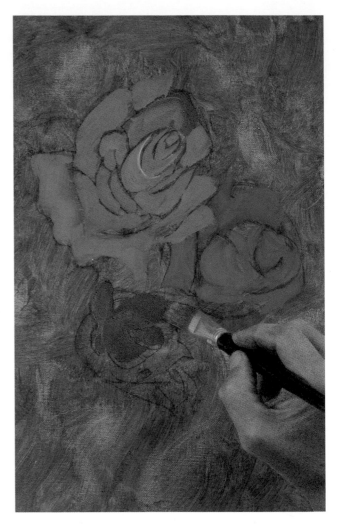

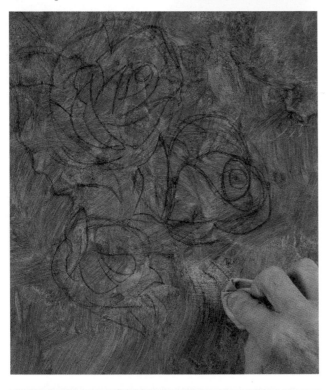

STEP 1

Build up areas of colour, continuing from one flower to another. Strengthen the amount of permanent rose in the mix to create a distinction between the two flowers. For the third rose, add some cadmium yellow to the mix and start painting the basic shape of the flower. Drag the colour across the petal.

STEP 2

Blend the petals of each rose into the others by gently dragging colour from one to the other, but take care not to lose the definition between them. You will see that when you drag colour into unpainted areas, the colour of the background comes through. Take a smaller no. 5 brush, go back to your original colour mixes and start to model the forms of the petals. Mark out the dark areas, without worrying about accuracy: edges can be tidied later.

BUILDING COLOUR

In a painting like this one, where flat colour is laid down initially and darker tones added, do not worry too much about making the colour solid in the early stages. When you start to add darker tones and blend them into the painting, you can strengthen the drawing and build modelling to make it more three-dimensional.

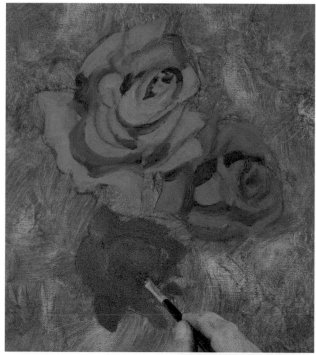

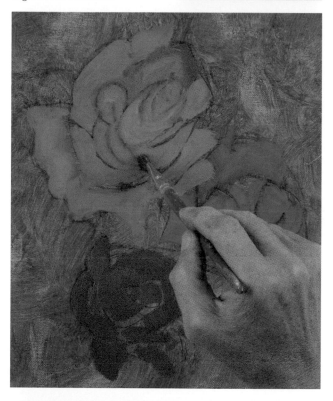

Use permanent rose on the yellow areas to warm them up. When all the flat colours are in place, you can start to blend.

RIGHT Using the soft sable brush, very gently and working in a parallel motion, blend the edges of the colours. Don't worry if your sable brush drags colour out of the petal shapes, as the background will be painted later and will obscure any marks. Using the blending brush as a stippling tool will move colour just a little.

STEP 3 ▶▶

STEP 4 ▶▶

4
roses

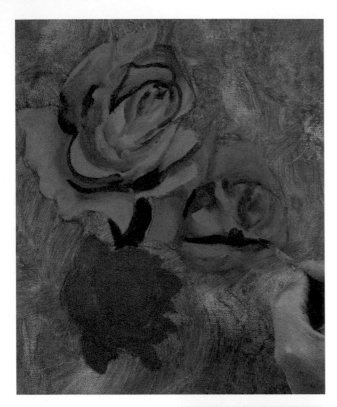

RIGHT Start with the top flower and add highlights around the top edge. Blend the highlights in using a flat sable no. 4 brush. Use a stippling motion, rather than a dragging one.

Work along the lower edge of the top flower, adding highlights and blending them in.

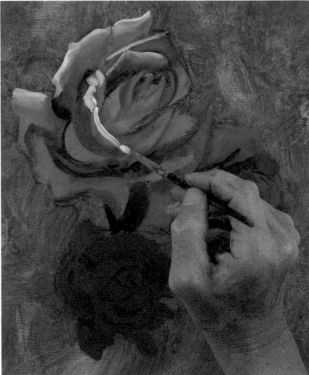

The main areas have now been established. The whole of one petal on the top rose is in shadow, so needs to be darkened. It is now time to redefine some of the darks, using a no. 5 sable brush.

RIGHT It is important to remember that each petal is wrapped around another. Keep this in mind as you start to build up your painting.

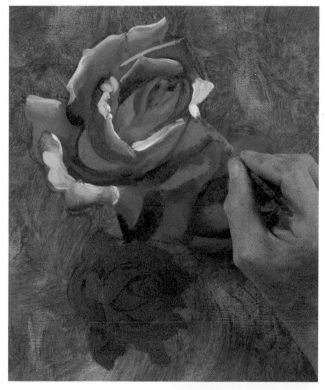

Use a soft sable no. 3 brush to blend; this gives the effect of the petals turning away from the light, The blending is gradually, rather than sharply, stepped.

PAINTING MEDIUMS

If you use linseed oil to thin your paint, as was used in this painting, it will help you to control the flow of the paint. This allows you to work in fine detail, as on the edges of the petals, for example. As the oil colours dry, they become easier to work with.

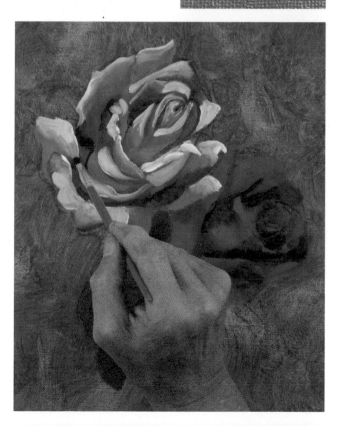

As you work, you are gradually lightening the whole top flower, dragging the lighter shades out and blending them.

Continue looking at the top flower, noting where the lights and darks fall and adding them, blending as you work.

STEP 7 ▶▶

STEP 8 ▶▶

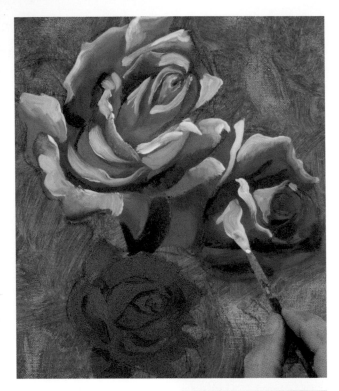

RIGHT Take a no. 2 sable brush and blend the colours. As you approach the heart of the rose, the highlights become smaller, so you need a smaller brush.

Work around the second flower, looking to see where light is falling to create highlights. Blend the light into the dark. Begin to define the areas of light and dark more carefully. Sometimes it is a case of simply stippling one colour into another.

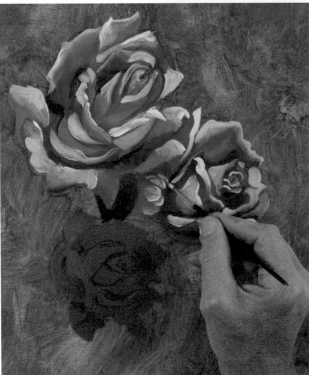

Note that the whole of the top bloom has been lifted out of the dark background. Now start on the second blossom, highlighting its top edge.

RIGHT As the lighter colour is applied, it drags up some of the wet middle tones underneath, helping to build up the modelling on the petals.

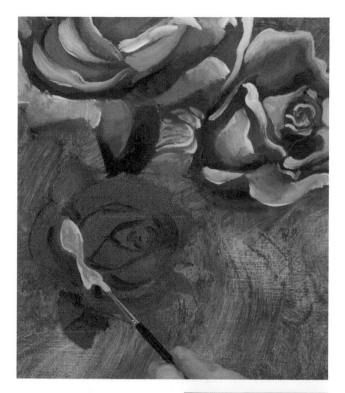

RIGHT The two pink roses now look too dark, so they will be made more creamy. Brush some colour into the darker areas and move it around with your soft sable brush, to reduce the amount of contrast in the bloom.

Drag some creamy colour into the pink. Add to the permanent rose some cadmium yellow and white and drag this into the darker areas to reduce the contrast.

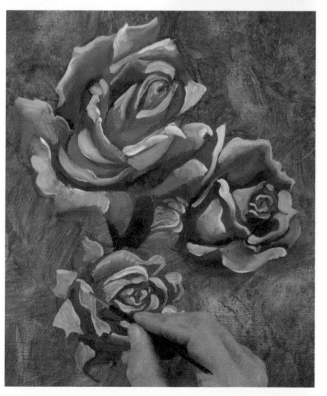

Start to work on the creamier rose without altering the colour of the paint too much, to allow the gold beneath to show through. Add highlights and blend as you did on the first two roses.

RIGHT Continue to look at where the light falls and add highlights in these areas. As you add highlights, you are also fine-tuning the shape of the flower and of the individual petals.

STEP 11 ▶▶

STEP 12 ▶▶

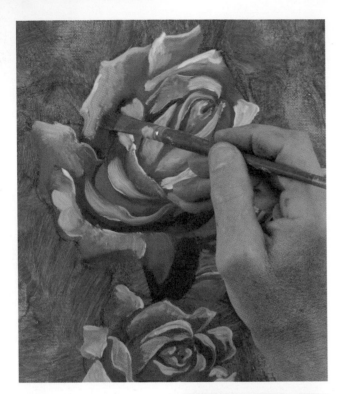

Take a sable brush to apply a mix of permanent rose and white to the two pink flowers. Use another sable brush to move the colour around.

Leave some areas of highlight unblended so that the brushmarks are visible.

MODIFYING COLOUR

If you are not happy with the colour you have created, as here where the pink dried out too dark, you can continue to modify it, as has been done here where the pink has been made creamier, to lift the tones of the whole painting.

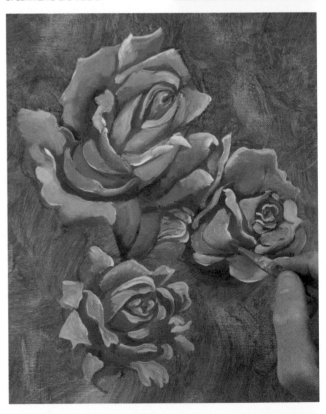

Now that paint has been dragged into the darkest areas, the contrast is looking too stark, so drag some colour into the whiter areas that are beginning to look too chalky.

RIGHT Work around some of the darks, redefining them. The colour is being moved around, but no new colour is being added. Rub some of the flower colours into the background.

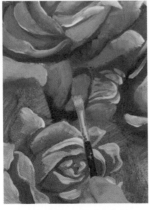

STEP 13 ▸▸

STEP 14 ▸▸

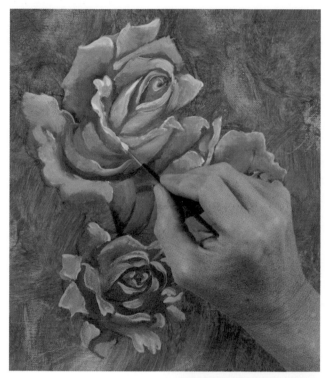

At this stage, the flowers are
nearly finished, so start to work
on the background. When the
background is added, any
necessary adjustments to the
flowers are easy to see and can
be made. Use Payne's gray and
viridian and rub this into the
background tones, without
making it too bright.

MOVING COLOUR

A large part of oil painting
is moving the paint around
on your ground to get the
effect you want. If you are
using linseed oil or
turpentine as your painting
medium, you will have
three to five days when you
are able to move the paint
around on your canvas.

Once the paint starts to get
stiffer, it blends itself, without you
needing to use a brush.

RIGHT On the second flower,
blend in some highlights around
the edges of the petals.

STEP 15 ▸▸

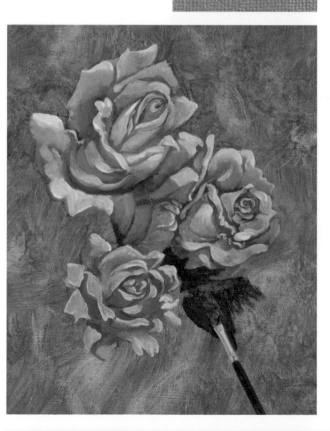

STEP 16 ▸▸

RIGHT Although a background is being added, to suggest a hint of leaves, the canvas ground is still visible. Use a hoghair brush and a scrubbing motion to work colour into the canvas.

Lift some areas of background out using a rag, to create a more abstract texture. This shows up the scumbled background of the canvas. Continue to drag background colour into the petals.

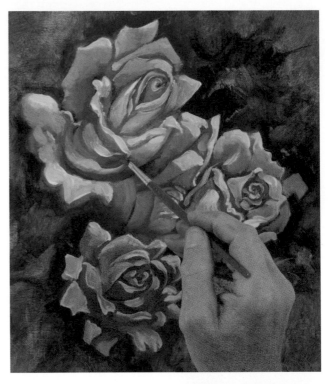

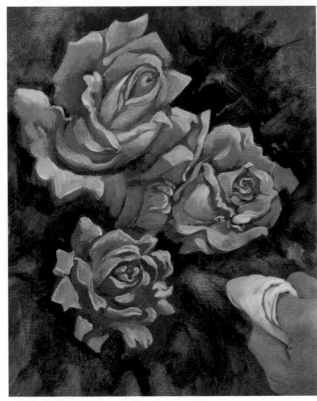

Use a fan brush to soften some of the tones. Always pull the fan brush in one direction only. This blends all the tones together, giving a softer focus. Don't take this brush too far into the background. Wipe your brush between each stroke so that colour does not build up on the brush.

REFINING SHAPES

As you add colour to your background, you will find that you are also redefining the shapes of objects in your work, in this case the petals: the darker colour is cutting out the shape of the petals. Dragging background colour into the petals also blurs their edges a little. use the colour of the background to define the shapes you want.

Steady your hand on a mahl stick, as you start to add highlights to the roses, using the same mix of permanent rose and white and a fine no. 2 brush. Add a little white to the background colour of Payne's gray and viridian and start to pick out one or two leaf shapes. Do not make these appear too much in focus, as this will unbalance the roses. Break up the leaf areas using the end of the brush handle so that the underlying texture shows through.

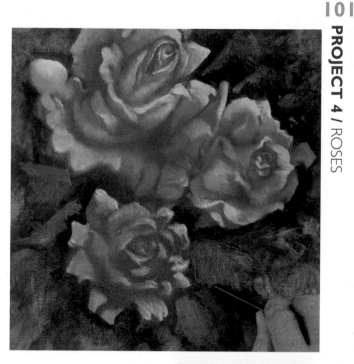

Rub in some lighter areas to give an indication that light is coming through the petals.

RIGHT Finally, there is one area that needs more work, under the large flower so add some definition here.

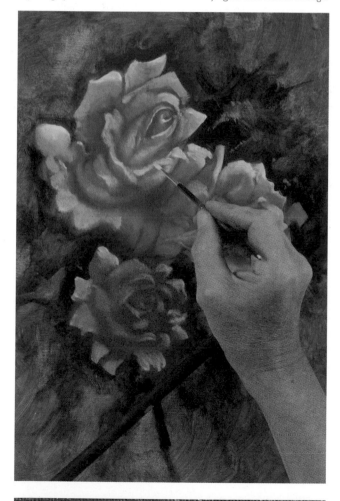

STEP 19 ▶▶

STEP 20

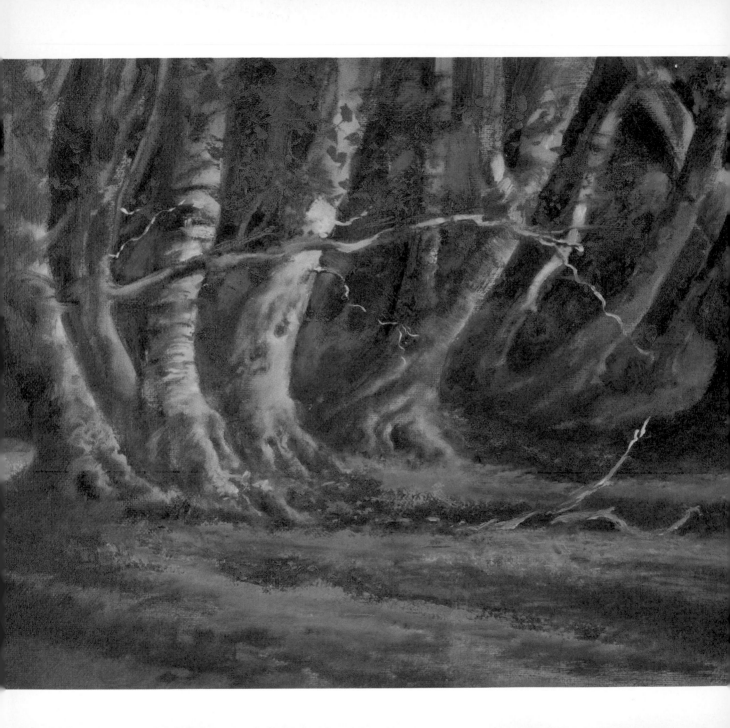

5
light in the wood
john barber
350 × 480 mm (13¾ × 18¾ in)

The fall of light and shade in a wood constantly changes the scene. At one moment, a branch catches the light and sparkles with colour; in the next, it is cast into shadow and a spray of leaves attracts the eye, caught in the sunlight. It is this vibration of shapes and colours that make trees and foliage the continual fascination and challenge for the artist. Plan the design of your picture with its pattern of light and dark areas to give you a structure, then choose the accents that help the overall plan of your picture. When you work outdoors, you will find that the visual excitement in nature outweighs the difficulties of drawing. Try to see what is before you as simple shapes and avoid the complexity of detail.

TECHNIQUES FOR THE PROJECT

Wiping out from dark

Scumbling

Building impasto in the lights

WHAT YOU WILL NEED

Charcoal
Brushes: flat hoghairs nos 3, 4, 5, 6 and 9; round sables nos 3 and 4; fan
Turpentine
Rag

COLOUR MIXES

1 Payne's gray
2 Viridian
3 Burnt sienna
4 Yellow ochre
6 Cadmium yellow
8 Cadmium red
10 Violet

LIFTING OUT

One of the advantages that oil painting has over the other media is that, because of its slow drying time, alterations can be made by moving paint that has already been applied rather than adding more paint. By working into a dark background colour, you can scrape, rub, or wipe through to the original surface, leaving a lighter area that draws your subject. Because this technique still leaves accidental traces of paint in the wiped areas, this can suggest light and shade. When you see that your lifted out area suggests what you were attempting to portray, reinforce this by further scratching or, if more accuracy is needed, begin to use your brushes.

This technique can be used to carry out a finished picture that will be in monochrome (single colour) in whatever colour was used for the background. You can also allow the texture of your background to play as great or as minor a part as you wish in your finished painting. The method can be used to complete the composition and modelling and allowed to dry before having colour glazed and scumbled over it. This separates the problem of form from the actual colour choice. The technique of lifting out learned from oil painting has been adapted for use in lithography, etching and monotype as the printing ink has a similar viscosity to wet oil paint.

1 Using burnt sienna and a little viridian, brush some colour onto a board. Scrub it all over. There is a lot of texture in this sketch. If you don't want the texture of brushmarks, you should use your brush in more of a stippling movement.

2 Now take a piece of kitchen paper and begin to move colour off the surface. Move the kitchen paper around to get a clean piece. Work in a dabbing motion to remove spots of colour, or in long sweeps to take out broad swathes of colour.

3 Using the kitchen paper in this way creates abstract shapes in your sketch. If you like the look of them and they contribute to your subject, keep them. If not, change them, either with kitchen paper or with the brush and painting medium.

4 Now dip your brush in painting medium and use that to modify the paint. The painting medium used in this sketch is white spirit, which dries quickly. Using the brush allows you to introduce more accurate modelling into your work.

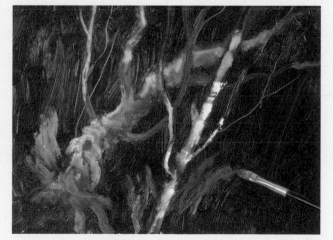

5 Use both the bristles and the brush handle to take out patches of paint. The end of the brush handle allows you to get fairly precise lines. When you are happy that you have established areas of light and shade, move on to add colour: here viridian.

6 Then start to introduce white areas to get some modelling into the tree trunks. If you choose to work straight into the background colour, wet in wet, you will also modify the colour and get a range of tones of brown, green and white.

This project is painted on a tinted canvas board. Sketch out the main lines of the composition using black charcoal. Use the stick on its side to get areas of denser colour. These form the basis of the thicker tree trunks. In this composition, the main lines are the shapes made by the tree trunks that frame the view.

BE BOLD

If your first lay in of paint does not please you, do not hesitate to wipe it out either completely or to a faint image that you can correct. Try to assess your picture at each stage and use your rag to get rid of any misjudgments that will cause difficulties later on.

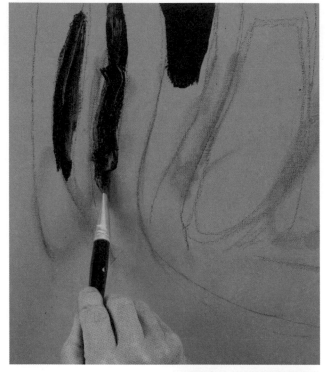

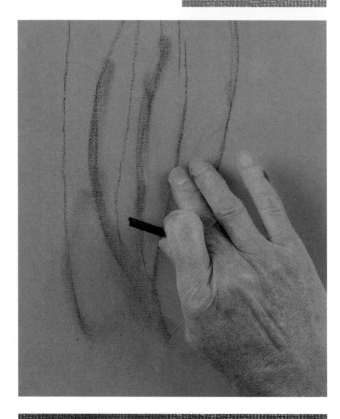

STEP 1 ▶▶

Using a mix of viridian and Payne's gray and a large round hoghair brush, start to block in the darker areas between the tree trunks.

RIGHT Build the base colour for all the tree trunks. Add paint using the brush, then take a rag and wipe some colour out. This immediately has the effect of introducing a range of tones for the tree trunks.

STEP 2 ▶▶

THINK BIG

Work with the largest brush you can and continue using it as far into the project as you choose. This will improve your paint handling skills and give your work a bold look. Learn what marks your large brush can make before changing to a smaller size.

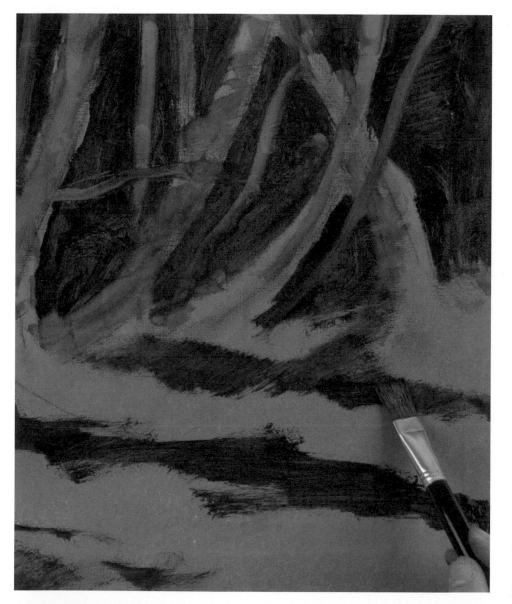

Establish the main lines of the trunks using the viridian and Payne's gray mix and wiping out areas to create the forms of the trunks and crossing branches. Then change to a no. 9 flat brush and using the same colour mix, start to indicate the forest floor.

STEP 3

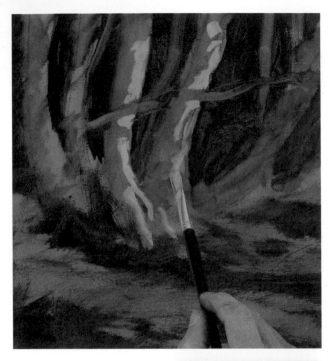

Go back to your Payne's gray and viridian mix and, using the edge of the flat brush, start to build up the shadow sides of the tree trunks. As with the lighter tones, building up the shadows also contributes to modelling the roundness of the trees. Work across your canvas from left to right, picking out all the areas that are in shadow. As you work, note that the colour you apply is modifying the colour beneath, so that you get a range of tones. The main areas of light and dark have now been established.

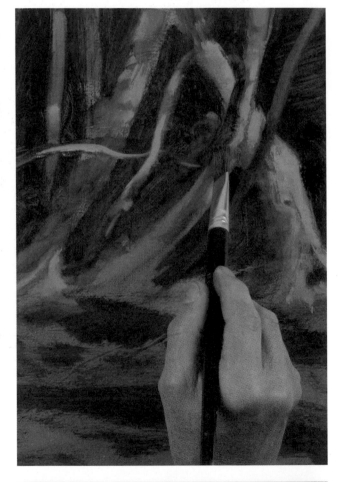

Add some white to your viridian and Payne's gray mix and use this to start to get some lights into the tree trunks. There are areas of white highlight on the right of each trunk. These white areas allow you to build up the roundness of the trunks.

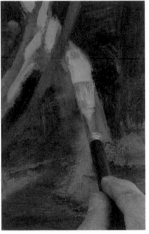

RIGHT Drag colour down the sides of the trunks using the no. 9 flat brush.

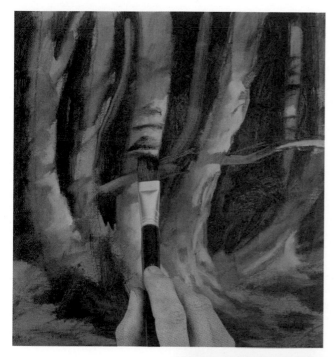

RIGHT Use the darkest Payne's gray and viridian mix for the central area of the glade, where there is least light.

Define the space between the roots of the two trees by adding your shadow colour. This establishes the two sets of roots as separate from each other.

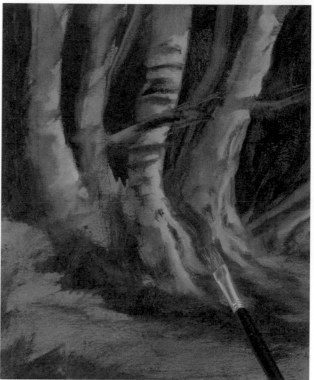

Start to get an indication of the texture of the tree trunks. Build up darker areas, using the tips of the bristles of the flat brush.

RIGHT Next, change to a smaller brush to work the gnarled tree roots, radiating out from the base of the tree.

STEP 6 ▶▶

STEP 7 ▶▶

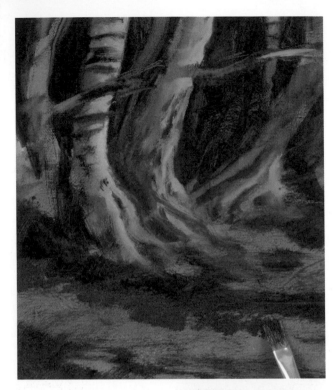

RIGHT There is often quite a
lot of green in tree trunks. You do
not want a series of brown tree
trunks: that is not how they
appear. Work some fairly bright
green into the tree trunks in
some places.

Add the green mix to the area to
the left of the trees. Work some
more of this paint into the tree
trunks where they are too
distinct. 'Lose and find' the shapes
of the tree trunks.

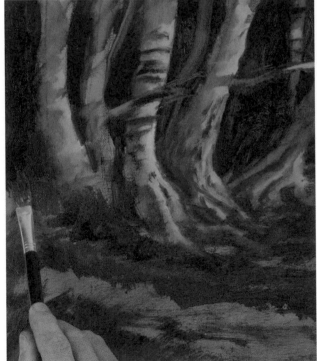

Return to the area of the forest
floor and use a mix of viridian
and yellow ochre to introduce
some green tones here. Use the
flat hoghair brush and follow the
contours of the earth and the
roots of the trees.

TONING IT DOWN

It is always possible with oil
paints to overpaint areas
that do not work. At this
stage in this painting, the
green on the left looks fine.
However, as the painting
progressed and the carpet
of cyclamen was painted in,
it looked too garish. This
was rectified by painting
over it with a mix of yellow
ochre, burnt sienna and
white to tone it down.

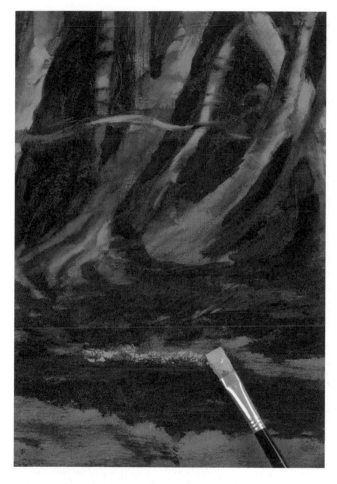

RIGHT Use a light mix of Payne's gray with plenty of white, for highlight areas on the forest floor. Hold the brush flat and pull it across the canvas, allowing the paint to be dragged along.

Mix ultramarine and violet and use this to start to indicate the carpet of cyclamens in the foreground on the forest floor.

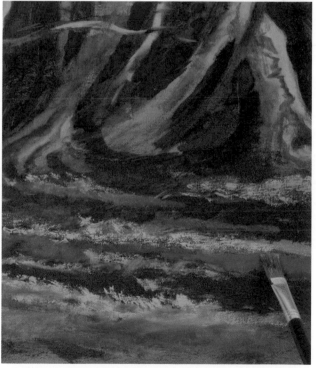

This is where you must begin to get a feel for the way the flat brush, resting lightly on the canvas, will make broken, irregular marks. A delicate touch is needed to suggest the tiny flowers. It is easy to over-estimate the amount of paint and the pressure you need on the brush. You need very little paint and the lightest of touches. Practise on a spare piece of canvas or board and remember that if your first attempt does not please you, you can wipe out all trace of the light paint and try it again.

STEP 10 ▸▸

STEP 11 ▸▸

5
light in the wood

Add some white to your cyclamen colour mix and use this to create even lighter patches in the carpet.

RIGHT Mix cadmium red and cadmium yellow to a fall tint and start to add foliage. Vary the angle of the brush so that the leaves vary in size and shape. Load your brush fully and lightly touch the picture surface with the corner or edge, leaving little broken shapes.

AVOID DETAIL

With natural subjects such as this one, it is important not to get too involved with details. There is no attempt here to render each individual flower that forms part of the cyclamen carpet. Instead, forms are suggested and built up using colour and brushwork. This can work more effectively.

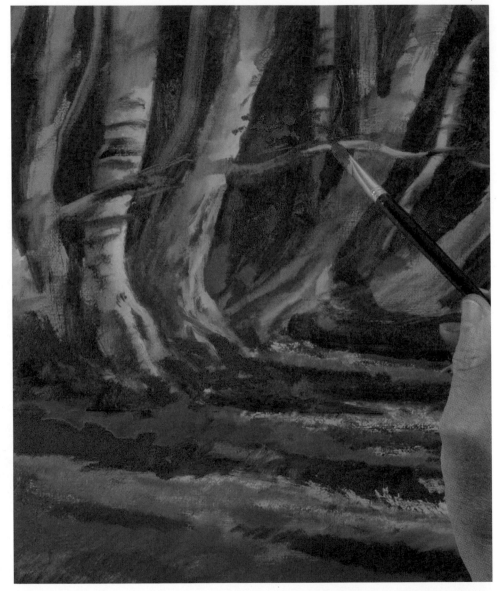

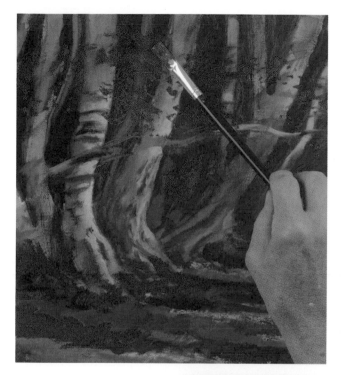

RIGHT With the no. 3 sable, go back to the reddish tone on the palette and indicate some fallen leaves on the ground. Indicate a twig catching the sunlight, then bring some red into the shadow areas, using a stronger tone of cadmium red and cadmium yellow, with no white in the mix.

Drag some more fall colours into the shadows of the foreground, again using the small brush.

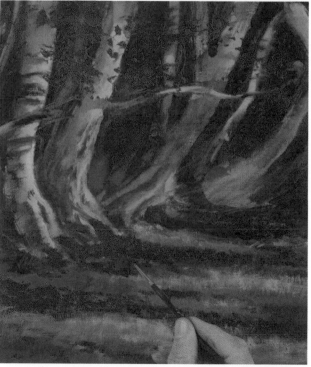

Touch more cadmium red into your fall colour mix and add more touches of foliage across the central area of the painting. It is very easy to overdo this and add too much light colour. If you do, it is sometimes better to let the painting dry before scumbling over or painting out the bright leaves with your background colour mix.

SCUMBLING TIPS

Part of the beauty of working in oils is that one colour picks up another and modifies it. However in a scene such as this, where you are building up modelling on the tree trunks, you may find that scumbling one colour over another lifts too much colour. If so, leave it until the paint is dry, then add paint with your brush or rag, so as not to lift the underpainting.

5
light in the wood

RIGHT Turn now to working on the trees, using the hoghair brushes nos 6 and 4. Go back to your white and Payne's gray mix, with a touch of violet added and use a no. 4 sable to make some accurate marks on the tree trunks.

Draw out the branch against the background. Where you are trying to reproduce sunlight, how the colours relate to each other is more important than the actual colours used.

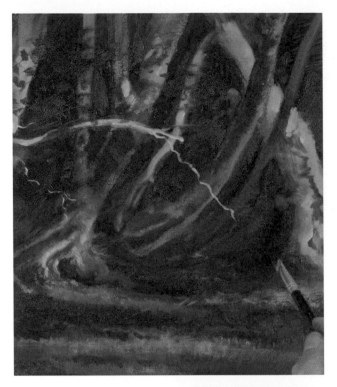

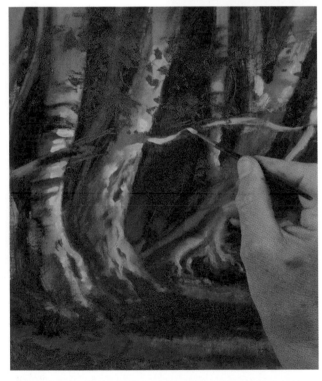

In a scene like this woodland glade, it's important to have some areas crisp and others blurred because they are not in the light. The shadow areas here do not have distinct shapes in them. Scumble using a hoghair brush and rub colour into the existing tree trunks. This colour will be a mix of viridian and burnt sienna with no white added, to make a soft green. Do this gently so as not to destroy all the modelling you have already built up on the tree trunks

A DELICATE TOUCH

Be very restrained in the amount of paint you put onto areas such as the cyclamen in this painting. It is better to simply rest the brush on the canvas. If you overdo it, wipe it off and start again. It is usually a good idea to test the weight of your strokes and the amount of colour on a spare piece of canvas with such delicate subjects.

Take the same light mix of white and Payne's gray you used for the branches to outline one or two twigs that have fallen on the forest floor, to liven this area up a little. These will have the effect of pushing the rest of the painting back. Then brighten the highlights on the trees on the left. Next, reinforce the light falling on the

trees using the hog brush. These areas of light should be concentrated in one or two areas, rather than spread over the whole painting. Define the darks, then work in more lights. Use the badger blender again to soften some of the marks. You may find that a fan is more useful for blending, but keep the touch light.

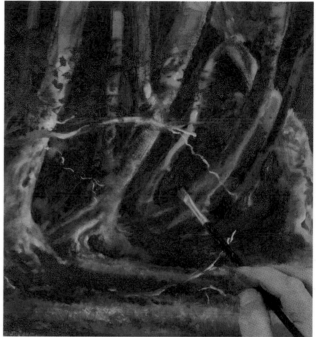

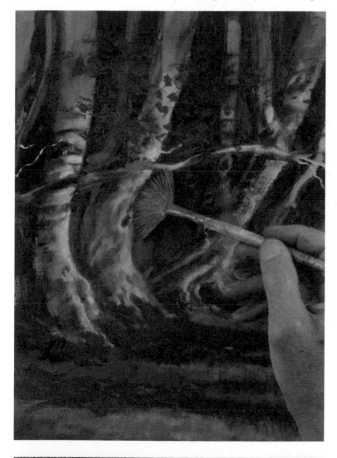

Redefine one or two of the darks between the trees to improve the drawing. Using the no. 5 hog brush and the original Payne's gray and burnt sienna mix, specify some areas in the darks to improve the drawing of the trunks and re-establish the pattern of darks and lights.

RIGHT Then use the colour you used for the cyclamen, ultramarine and violet, with thick white added to introduce some highlights to the cyclamen. Do not overdo this: you are aiming for tiny dots of colour.

STEP 17 ▶▶

STEP 18

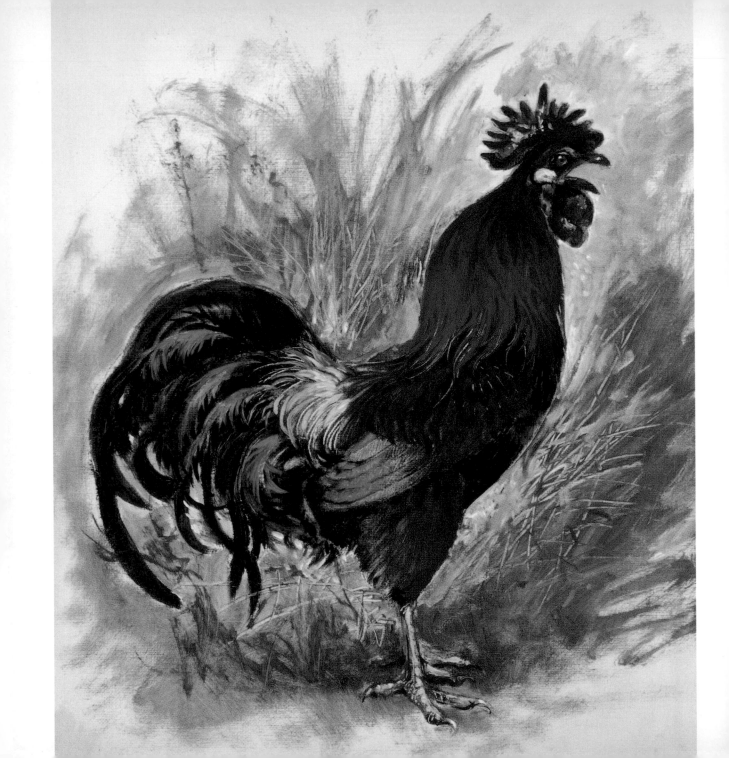

cockerel

john barber

325 x 310mm (12¾ x 12¼in)

You can use oil paint of varying consistencies on textured canvas in the 'traditional' manner. However, using a smooth canvas board to paint on lets your brushmarks flow and blend, making it possible to render the finest details. In this study of a cockerel, once the silhouette of the bird has been established, you can concentrate on detailing the plumage and learning the flowing qualities of thinned down oil paint, without the complications of pictorial composition. Notice how the cockerel stretches to his maximum height to give his warning cry. This is an iconic shape that has been used in art and design in all cultures as a sign of readiness to compete.

WHAT YOU WILL NEED

Smooth canvas board
Painting medium
Chalk
Brushes: round sables nos 2 and 5; flat sable no. 6; flat hoghair no. 4

COLOUR MIXES

1 **Payne's gray**
2 **Viridian**
3 **Burnt sienna**
4 **Yellow ochre**
6 **Cadmium yellow**
8 **Cadmium red**
11 **Cobalt blue**

TECHNIQUES FOR THE PROJECT

Working fine details

Using thinned paint and soft brushes

Scratching out

USING THINNED PAINT AND A SMOOTH GROUND

This study of an old dog will give you practise in the use of thin paint on a smooth surface. In solid or 'impasto' painting you need stiff brushes to push the paint about, but working on a surface with no texture, you can use soft brushes with thinned-down paint to make delicate gradations with the softest of marks as the brush hairs trail behind your strokes and imitate the curves of nature. Then, with a stroke of a soft sable, you can soften and blend your marks. Having blended your brushmarks, you will find that the smooth surface is still slightly damp; this gives you the chance to add further delicate details as any subsequent marks will soften as they are dissolved by the oil on the surface. In the project that follows, this technique is taken one step further and the canvas is 'oiled out', or dampened, to start with.

Practising this kind of technique will gradually give you control over tone and texture, but it will take many brushstrokes before you gain the essential 'touch' that will dictate the way your paintings look. The way that musicians handle their bows decides every sound they make: it will be the same with you and your brushes and the marks they make.

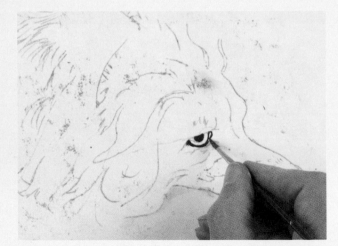

1 Sketch out the basic shape using charcoal or chalk. Working on a smooth surface, you will be able to draw accurately. Use a small sable brush and outline the eye and the pupil. The oil paint is mixed with medium to make it flow.

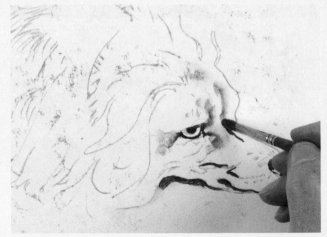

2 The blending brush is going to be used to work the colour around. Put the basic shapes on with the paint very liquid so that you draw with it. Then take the blending brush, which is quite damp with the medium and use it to blend the shapes out.

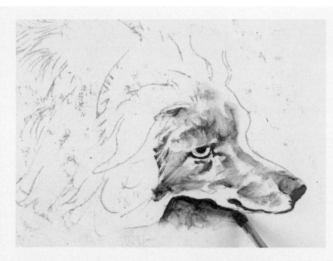

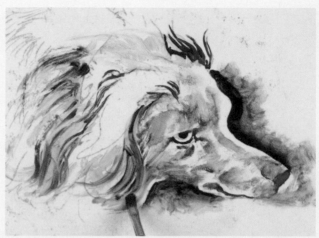

3 Continue to draw in details and blend them out. Each time you add a shape, brush it out with the blending brush, damp with medium. On a smooth surface like this one, where there is no texture, every mark shows.

4 Wet the areas over the ears with medium. The medium is slightly tinted with colour it has picked up. When the paint is applied to this medium, it will slide around easily and create the soft effect of the hair on the ears. Blend this out.

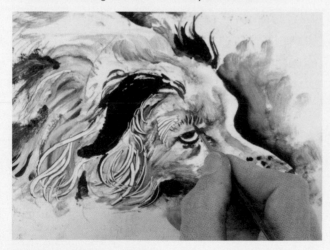

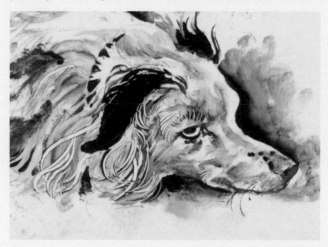

5 Take the brush loaded with colour, to work the dark areas of the ears, where there is no white at all. Indicate the eyebrows. These are detailed, to make the facial expression look right. Then put in an indication of the collar.

6 Define the area where the dog ends and the background begins. Use the end of the brush handle to flick some paint out, creating greater detail in the hair. The black hair around the neck can be quite soft and the end of the nose is very subtle.

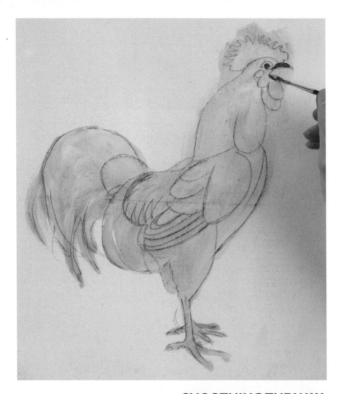

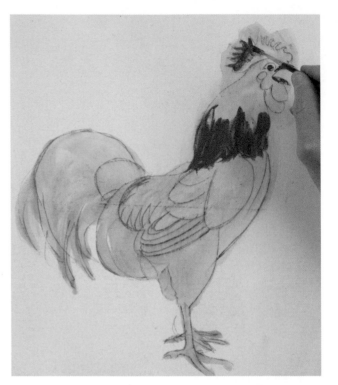

Trace down the main lines of the subject using chalk or, if your drawing skills are good, draw the main lines freehand. Note that there is no perspective in this painting so once the silhouette is established, the rest of the composition will follow fairly easily. Use pure cadmium yellow of a very thin consistency for the eye and then for the beak. Then work some of the cadmium yellow into the feathers. The thin paint is running easily on the oiled-out canvas.

SMOOTHING THE WAY

If you wish to paint in a smooth, flowing style, but do not want to apply paint that has been thinned down too much, take a clean rag moistened with a mix of two parts turpentine to one part linseed oil and wipe over the canvas before you start painting. This will help every hair of your brush to leave its individual and unique mark.

Look at the areas of the head. Use diluted pure cadmium red here: this works almost like a tinted varnish. Since the paint is not being worked in an opaque manner, the brushstrokes will be apparent on the canvas. Add a little Payne's gray to the beak so that it is not quite so bright. Again use a small brush for this.

RIGHT A spot of solid Payne's gray forms the pupil. The setting of the eye is made with one or two dark details.

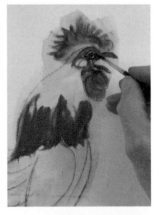

STEP 1 ▶▶

STEP 2 ▶▶

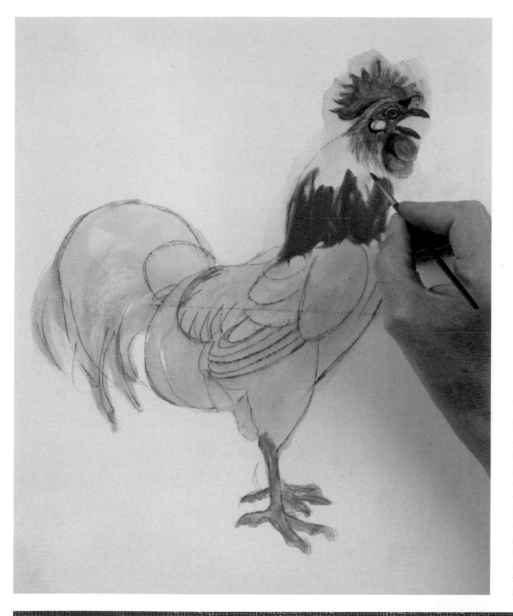

BE ECONOMICAL

If you are unable to continue painting the next day, lift each colour carefully from your palette with a knife and lay them, in the same order, in a shallow dish or tray and fill it with water. As long as the paints are covered by water, they will remain fresh and will not harden. Simply pour off the water and return the paints to your palette when you resume painting.

Use the cadmium yellow and Payne's gray mix on the legs. These are quite light but some darks can be added later to get some modelling on them. The absolute outline is not critical at this stage. Work up to the first joint. Blending takes place because you are working on a wet surface. The modelling occurs without too much extra brushwork. Use Payne's gray for the nostril and the area where the comb falls over the beak. Put some Payne's gray into the comb at the top of the head to get some modelling in here. This can be added to later, as the canvas starts to dry out. Cut out the linear details on the neck, again using a fine brush.

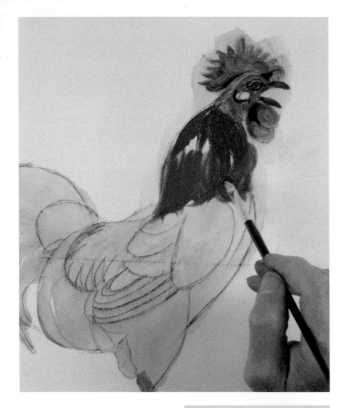

RIGHT The next stage is worked with pure burnt sienna and a bristle brush, out along the wing. When the bristle brush is used every hair registers a mark.

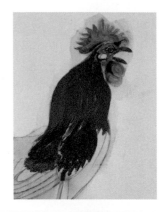

Continue working over the wing feathers, using the bristle brush. The far wing sits slightly proud of the bird's profile.

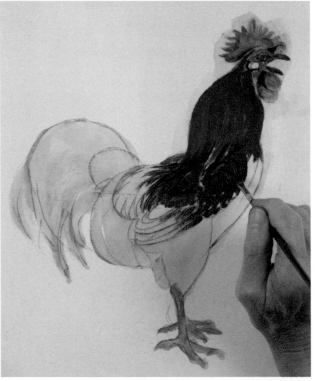

Mix some burnt sienna and cadmium yellow to make a rich orange colour and start working down the feathers.

RIGHT Add some cadmium red and burnt sienna to get the dark tones up near the head. Use the brush in a stippling fashion so as not to drag colour out. The wet paint is easily moved, so you may need to go back over what you have already worked to put colour back in.

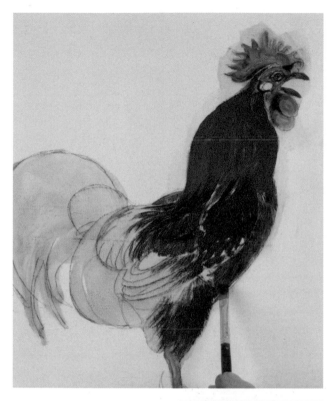

Use the same green on the front of the breast, then work the tail feathers, in one direction only and following their shape. At this stage, draw in the feathers in the direction of growth only: detail can be added later. Paint in the wing feathers using the same colour, then add more Payne's gray to the mix for the darker areas. Stipple the paint on the underside of the cockerel. Then work some of the same colour mix into the breast feathers.

OILING OUT

Often when working on a painting in oils over a period of time areas of paint may have dried at different speeds and some will become flat and dull. Wiping over the picture with a small amount of linseed oil will restore the brightness and depth of colour. You can also use 'retouching' varnish for this purpose. A matt or gloss varnish can be added later, after the painting is dry.

The brush scores into the colour, giving some texture and also indicating the direction in which the feathers grow.

RIGHT Work down toward the feathers on the leg. The next colour is a mix of viridian and Payne's gray. It is not necessary to dilute the paint as the canvas is already wet. When brushing in these colours, take your brush in the direction the feathers grow, so start at the top and work down.

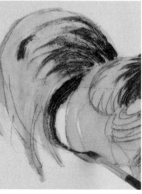

STEP 6 ▶▶

STEP 7 ▶▶

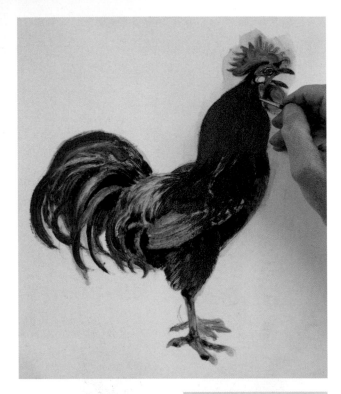

RIGHT Use burnt sienna for the golden feathers on the breast. The paint is now beginning to build up as the surface is drying. You should be able to get some rhythm into your brushstrokes.

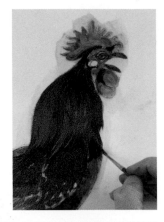

One colour is cutting into another. The burnt sienna is being used pure, but is starting to look darker as it increasingly builds up on the canvas, blotting out any remaining areas of white canvas.

The basic shapes and colours are now established, so it is time to start adding details. For these go back to the sable brushes, so put down the hoghairs. You do not need to do much blending as the canvas is still wet.

RIGHT Using burnt sienna, go back to the head and start to add details. Mix some Payne's gray into the burnt sienna and flick this into the edge of the head where the feathers are darker.

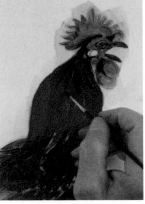

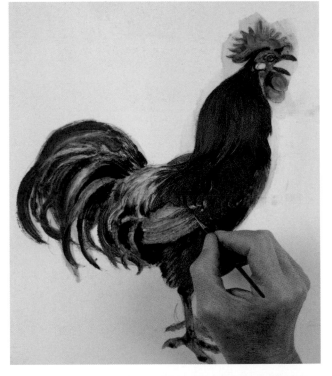

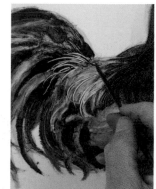

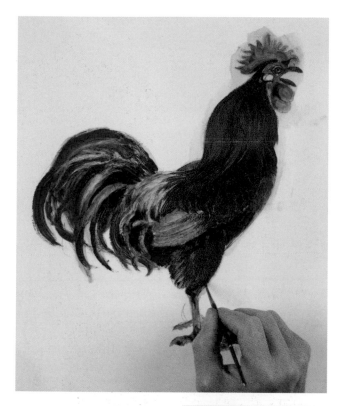

RIGHT This same technique is used on the legs, raising highlights so that you can see where the scales on the leg should be. Sometimes, by scraping out you achieve a result that is more effective than adding more paint. Add some more tail feathers, at this stage using the hoghair brush and viridian.

Then drag some Payne's gray into the colour you have and work over the feathers with this.

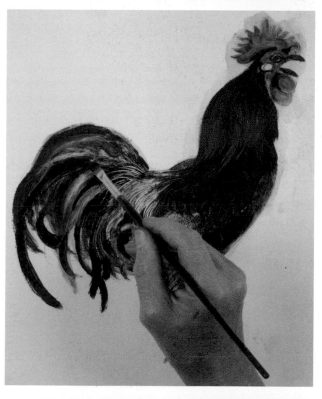

Drag the colour into the feathers, establishing the rhythm of where the feathers fall. Dab the colour on using the brush flat to create the layered effect of feathers. Then drag some darker colour into the underside of the leg, to give it a little modelling.

RIGHT Use the end of the brush handle to scrape some paint out. This re-exposes the colour of the canvas and creates a ridge of paint as you move it along.

STEP 10 ▶▶

STEP 11 ▶▶

6
cockerel

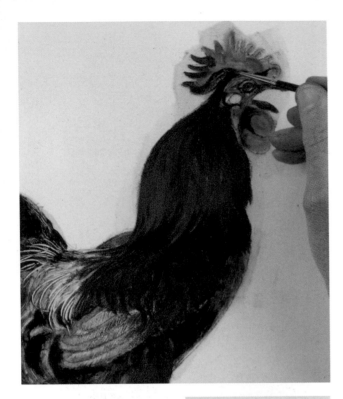

RIGHT Scrape off some of the paint on the tail feathers, to give areas of white highlight, then add some blue highlights. Take a no. 6 flat sable to blend some of the colours. Blending also gives an indication of more subtle curving shapes for the tail feathers.

Flick some dark paint into the tail feathers using a very fine sable brush and just flicking the canvas surface with tiny triangular-shaped areas of colour, to continue to build the shape of the feathers.

Add some slightly darker colour to make the crest more dramatic. Now is the time to strengthen the red of the head. Because this was worked into the wet canvas it is looking too pink. It has also bled.

RIGHT Use pure cadmium red on the comb. Drag the yellow colour of the neck feathers down, using a dry brush. Scrape off some of the paint in this area to get some linework into it. Add some pure white to the wattle and add a highlight to the beak.

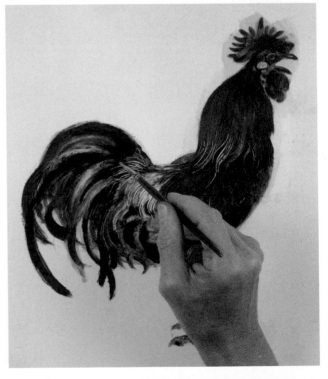

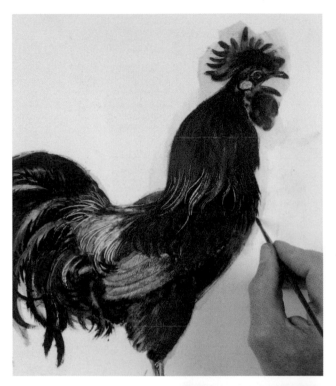

RIGHT Where the feathers are lightest on the back and you scratched out some paint, add some light tones. This will disturb the underlying colour, so that you get a mixture of colours. Use white for this, which will drag up the colour that is there and start to modify your white, making the whole area more natural looking.

Create highlights using a mix of cobalt blue and white. Then, add a tiny white highlight to the eye.

Move back to the breast feathers and add some darker tones here.

RIGHT Using Payne's gray, indicate shadows under the flight feathers. The eye now needs to be made more prominent, so outline it with Payne's gray and bring a little red in too.

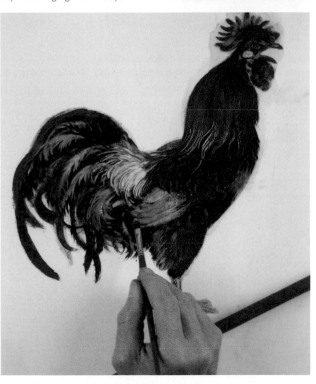

STEP 14 ▶▶

STEP 15 ▶▶

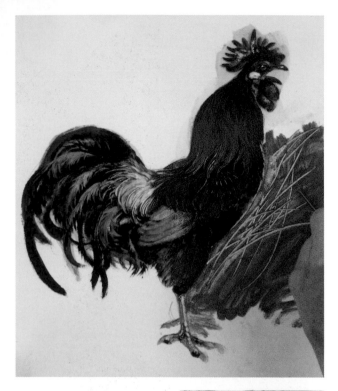

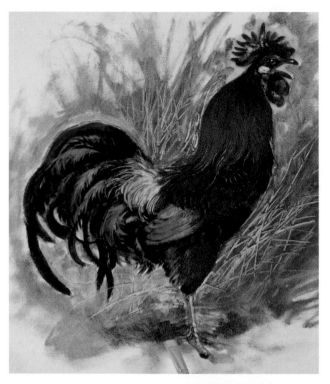

Rub a thin wash of yellow ochre and Payne's gray into the background area. Then use the end of your brush handle to take out some lines of colour.

RIGHT Work in sections of the background area, to be sure that the paint does not dry out before you have time to scratch it out. If you pick up any of the colour of the cockerel, brush it out into the background colour and it will likely disappear. If it does not, you can always overpaint.

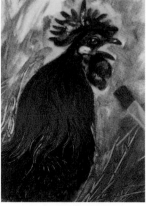

Try not to work all your marks in the same direction: you are aiming to give an indication of grasses or straw. If the background starts to dominate the cockerel, highlights can be added to him to bring him back to life. Add a little viridian to the mix to create areas of shadow around the feet.

A CLEAN BRUSH

When blending colours in the final stages of a painting, you will find that you have to clean your brush between each brushstroke so that you do not drag up underlying colours. In this painting, you would not get the iridescence you are trying to achieve in the tail feathers if you do not keep your brush clean.

RIGHT Using a mix of yellow ochre and burnt sienna, work some finer lines. Work around the head using a slightly whiter mix. This adds definition around the head, by cutting it out. Blend the colour in this area into the background colour.

Finish by bringing out the canvas colour again to create the profile of the head and back.

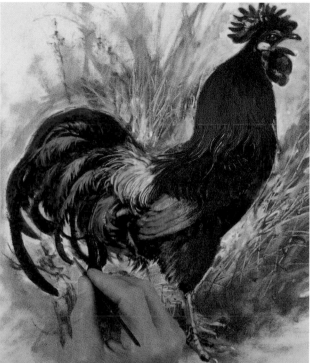

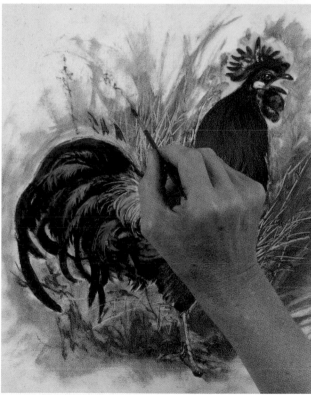

Add some white lights on the tail feathers and in front of the breast. Add some white highlights to the front of the legs and on the feet. Now work some tiny white and yellow ochre areas under the belly and under the tail feathers. This pulls the cockerel from the background and refines the details of the feathers.

RIGHT Finally, use the end of the brush handle to flick out some details around the feet.

STEP 18

STEP 19

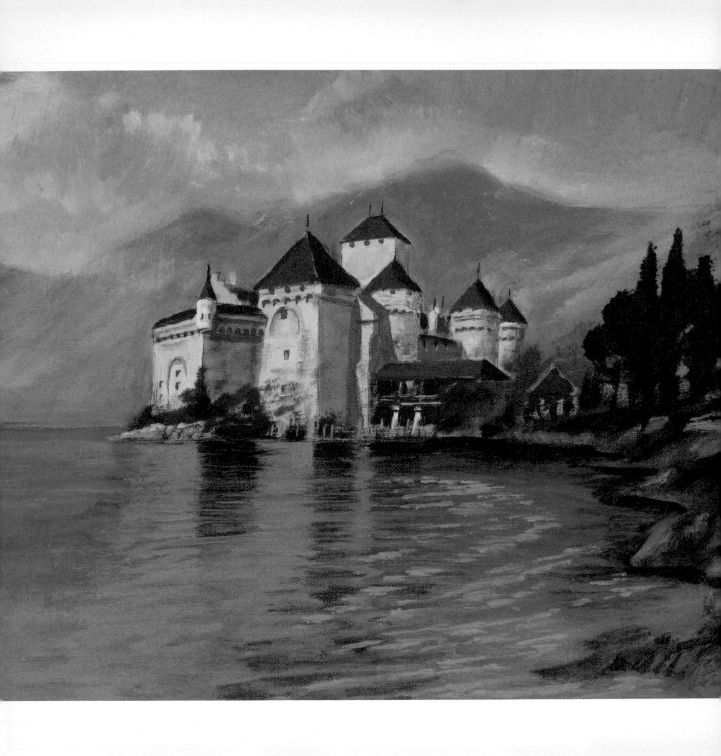

7
castle at chillon
john barber
280 x 390mm (11 x 15¼in)

The castle at Chillon is situated on a lake against a backdrop of mountains, near to Lausanne in Switzerland. For this project, it is important to make an accurate drawing of the castle itself: the success of the painting flows from the accuracy of your initial drawing. In addition, look closely at where the light falls and how the light casts shadows onto the different parts of the castle. With an architectural subject like this one, remember that you can decide the degree of finish. Accurately rendering every window, turret and detail is less important than creating a believable whole. If something is too detailed or too complicated for you to include, then omit it from your painting. Always simplify where possible.

TECHNIQUES FOR THE PROJECT

Architectural drawing

Rendering light and shade

Creating reflections

WHAT YOU WILL NEED

Tinted canvas
Tracing paper
Graphite pencil, 2B
Brushes: flat hoghairs nos 4, 7, 9 and 11; pointed sables nos 2 and 5
Painting medium
Mahl stick

COLOUR MIXES

1 Payne's gray
2 Viridian
3 Burnt sienna
4 Yellow ochre
6 Cadmium yellow
10 Violet
12 Ultramarine

LIGHT AND SHADE ON GEOMETRIC SHAPES

In the project that follows, painting an old and picturesque European castle, the main effect is of strong light falling on ancient walls, achieved by concentrating all the lightest patches on the building itself and keeping the rest of the picture subdued and relatively dark. This little study shows how to achieve this effect on a much simpler subject. As early as picture 2 on this page you will be able to recognise the subject matter from one flat white shape, painted on a tinted grey canvas, even if you cannot see any of the pencil lines. By picture 4 the composition is virtually complete and you will still have only painted three patches of colour.

Learning to establish the position of the lightest and darkest areas in your picture early in the work will clarify the composition so that you are not struggling to make these vital decisions later on when you should be refining and strengthening your original impressions, rather than changing them. As well as studying these step-by-step photographs and practising this little study for yourself, you may wish to make up similar little scenes, perhaps changing the angles from which light falls, as you build your understanding of light and shadow. Repetition of the technique should give you confidence when you decide to tackle the castle at Chillon.

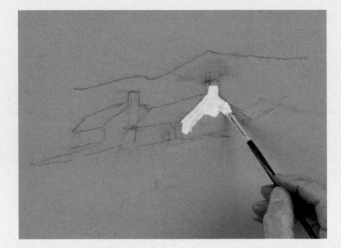

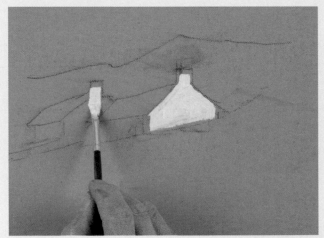

I As in the project that follows, the canvas is tinted with a mix of ultramarine, burnt sienna and lots of white to make it opaque. Mix white and yellow ochre to establish the lightest tone and create shapes for the first triangular roof and chimney.

2 Use the same colour mix and a flat hoghair brush, to create the sunlit end of a second building next to the first. Again keep the shapes simple: the chimney is a rectangle, painted with one stroke of the brush and the wall is essentially a triangle.

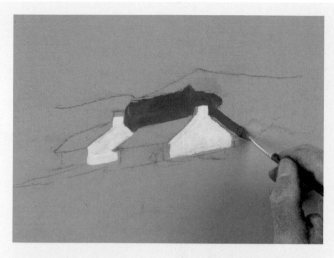

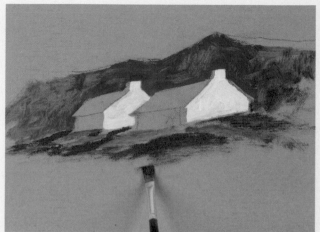

3 Mix colour for the hillside. This is ultramarine and Payne's gray. Start to work this between the two white buildings.

Outline around the chimneys, cutting them out against the colour of the hillside, then work this colour around both cottages.

4 Use cobalt blue and burnt sienna for the stone wall. Scrub this into the canvas to create the tones for the foreground. Add some white into this to create some variation in tone and work this over the area of the foreground.

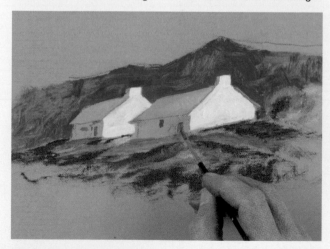

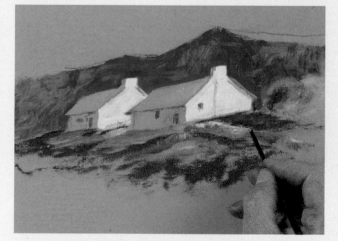

5 Introduce some blue and white into the roofs and use the same colour mix to indicate the windows and the door details. Then use this colour mix for the cast shadows of the chimneys and the rooflines, to build up your study.

6 The principle is to allow your tinted ground to do some of the work. You can also use the end of the brush handle to take an area of the sketch back to the tinted canvas to create highlights or variations in tone through the study.

7
castle at chillon

Draw in your horizon. Having traced your subject down, take a no. 3 and a no. 6 brush and start to establish all the light areas. It's possible that the background tint will play a part in the final colour scheme. The tones of the castle fall into light and shadow. Add the slightest hint of yellow ochre to white to give you a creamy tint for the lighter areas. Don't over-thin the paint so that you get a good colour. As you pick out the light areas, leave the shadows and areas of detail.

ACCURATE DRAWING

If you copy the painting here, that will be good drawing practice. If you feel your drawing skills are not up to this, then enlarge the painting on a photocopier, rub the back of the copy with charcoal and trace over the outline with a hard pencil. It is better to attempt it freehand, with a view to improving your drawing skills.

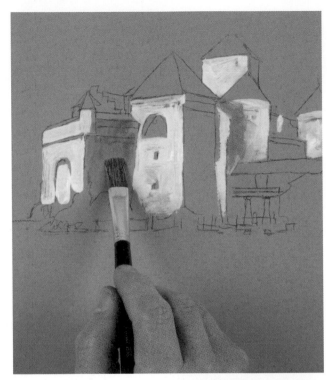

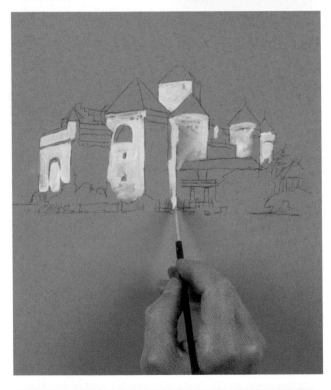

Don't attempt any blending at this stage. Using a flat hoghair brush, here a no. 6, means that as you draw it across the canvas you get a flat edge that can be used as your drawing edge. A variation in the thickness of your paint gives some texture to the stonework.

RIGHT In painting the white on the circular towers, remember that the underside of the towers is a slight curve. This curve helps to give a roundness to the shape of the towers.

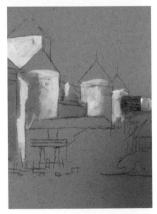

STEP 1

STEP 2

RIGHT Now take a touch of Payne's gray and burnt sienna to glaze some colour into the shadows. Make sure that on the right-hand side of the towers you leave some background tone showing through. This gives some modelling on the towers.

BRUSH SIZE

If you feel uncomfortable with the size of the brush shown here, go down to a no. 2 or 3 (a no. 6 is being used in the early stages of this project). However, keep your work loose: it is easy to get too tight and niggly if you use a very small brush, so keep this in mind when choosing which brushes to use.

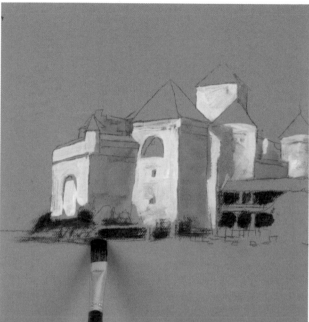

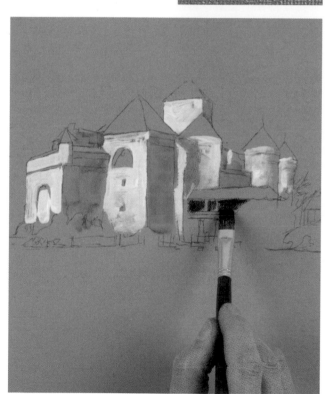

Take some of the Payne's gray and burnt sienna and drag some thick paint into the shadows. To the right, put a little shadow under the small building by the entrance. Here, use the paint fairly dry and leave the texture of the canvas to do some of the work of building the shadows.

RIGHT The dry brushwork gives an indication of the shape of the rocks around the base of the castle. To the right there is a dark area of bank by the lake, so use the same colour mix to give a neutral tone, establishing the shape at the base of the castle.

STEP 3 ▶▶

STEP 4 ▶▶

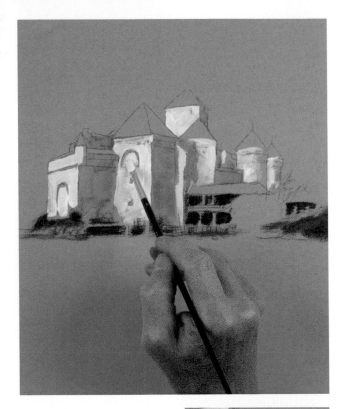

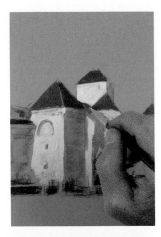

RIGHT Mix up some burnt sienna and white for the roofs. The flat hog brush is ideal for drawing straight edges. Scrub the paint into the areas of light on the roofs.

Add a little more white to the burnt sienna and paint the roof of the drawbridge and the area in shadow. Use the darker burnt sienna and white mix, with Payne's gray added, for the shadow areas on the roofs.

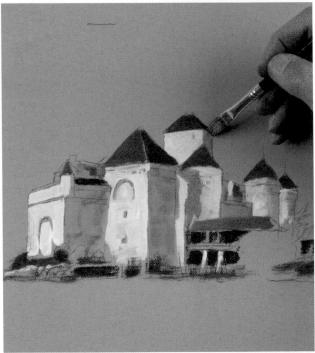

Now fill in the light area under the arch. Look at your painting so far and check that you have established all the areas of light and shadow correctly. Add in any lights you have missed.

RIGHT Then, indicate some light on the blocks. Before working any further, get some colour onto the roofs, so that all the main areas of castle have paint on them.

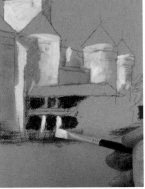

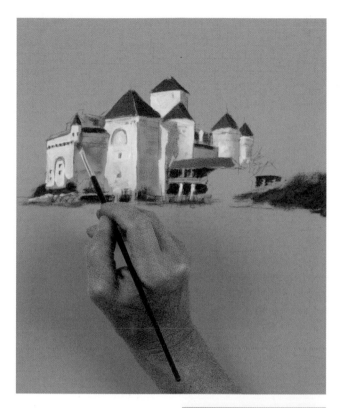

RIGHT There is also an area of dark in the top part of the arch and another at the top of the rounded turreted tower. When adding detail to the tower, make sure your marks follow the curved roof of the tower, otherwise your marks will not look convincing.

It's now a good time to look at the detail of the shadows. Add some linseed oil to the mix you used for the dark details and use this to make the lighting on the castle more dramatic.

On the main square tower, the shadow is very small as the angle is so acute. Put the three little windows into the top of the tower in the centre. Place them as accurately as you can but it is not necessary to measure.

RIGHT Work some oval shapes for the machiolations (projecting battlements). Don't count too accurately, just place enough to make the tower 'work'.

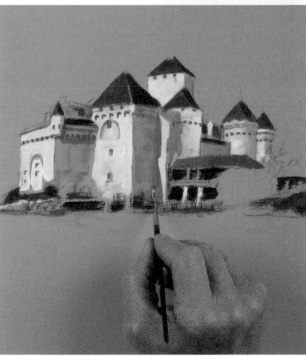

STEP 7 ▶▶

STEP 8 ▶▶

castle at chillon

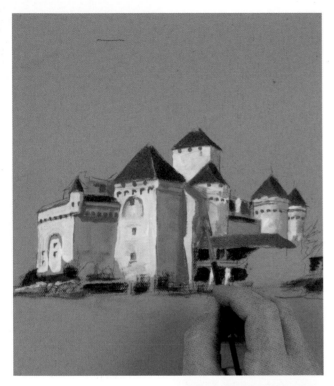

RIGHT Slightly increase the contrast between the light and dark sides of the roof, then blend this to give a gradual change of tone. Colour blending is affected by the texture of the canvas. If you do not want to make use of the texture of the canvas as part of your colour mix, make your paint thicker.

Strengthen one or more shadows as you continue to look for areas of detail you have missed.

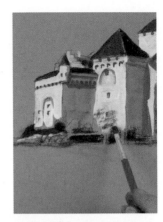

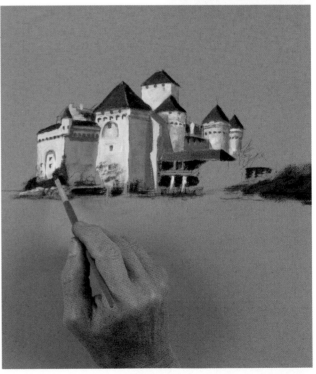

Add some darks to the right-hand side of the large tower, where the colour now appears too flat. This needs cutting out more strongly.

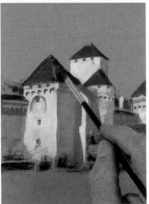

RIGHT Look at your painting and go around and fill in any details you may have missed on the façades. Here an area of roof had been missed.

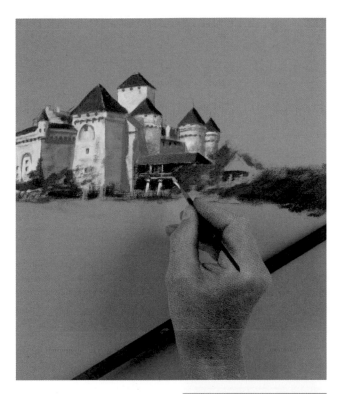

RIGHT There is a view through the archway, so add that in now. Follow the shadow down. Using your lightest stonework colour and the sable brush, clarify some of the lighter areas.

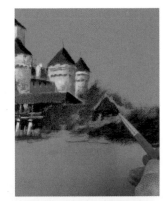

Trim up the edges of the shadows using the same paint and sable brush.

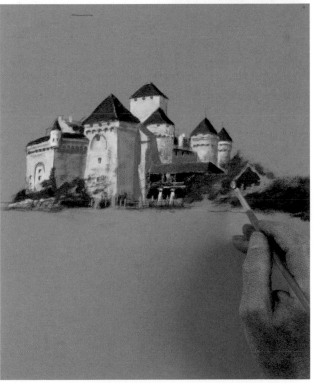

Start to add some detailing under the entrance canopy. Use the same dark tone you used for the buildings to paint the posts. Take some of the cream colour you used on the lightest parts of the buildings and working with thin paint, work the detailed posts and railings. (If you add too much colour, you can blend it away.) Use a mahl stick to steady your hand.

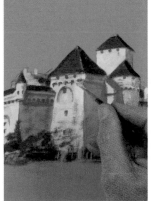

RIGHT Brush into the crenellations to soften them.

STEP 11 ▶▶

STEP 12 ▶▶

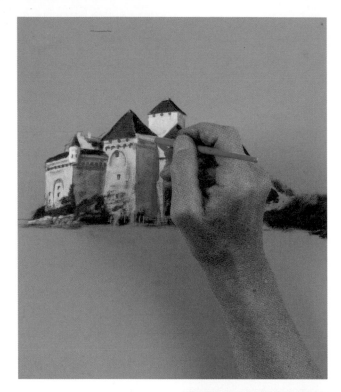

Take a no. 11 brush and mix up some ultramarine and white and test it on a scrap of canvas. Outline the line of the mountains using chalk. Then start to block in the mountain, beneath the chalk mark, using the brush fairly flat. Apply enough pressure to the brush so that the hairs are flat to the ferrule to help you to drag the paint across the canvas. This depends on the flexibility of the bristles. Work from left to right.

DRAWING MARKS

Don't worry too much about visible drawing marks. These can be removed when the paint is dry, if they are not overpainted while the background is being coloured. If the drawing marks modify the colour of your paint in a way you don't like, you can always overpaint.

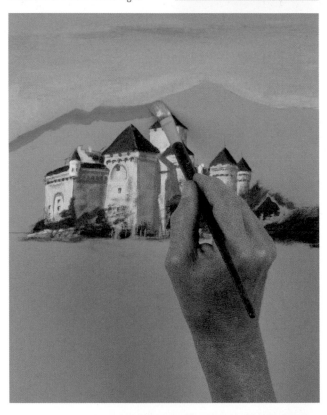

Make the little turret a bit lighter, as it is the nearest point on the castle to the viewer's eye. The sticky paint helps to give the look of crumbling masonry that is so attractive on old buildings.

RIGHT Before moving on to the background, look all over the building and check that you have not missed anything. Here cadmium red was worked into an area of roof that had been missed. Warm up the roofs to make them more lively.

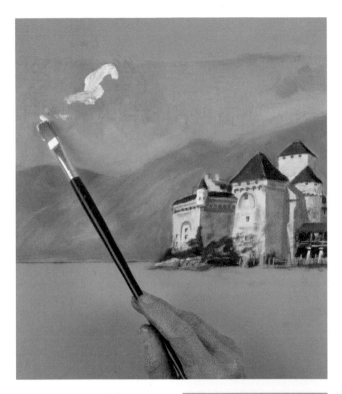

The mountains don't need to be dramatic as this would flatten the building. The sky can be more dramatic if you want it to be. Use the blue for the sky and work it across the mountain, to render those areas where the light catches them. Now work some of the mountain colour into the sky. This brings the eye back down into the centre of the painting. Go back to a slightly stronger ultramarine and violet mix and pick out some areas on the mountains.

COLOURED GROUNDS

When you work on a tinted canvas, use the colour of the background in your painting. In this project, the paint used for the mountains was kept deliberately thin so that the grey of the tinted canvas comes through helps to give a sense of distance for the mountains. It also adds texture to the mountains.

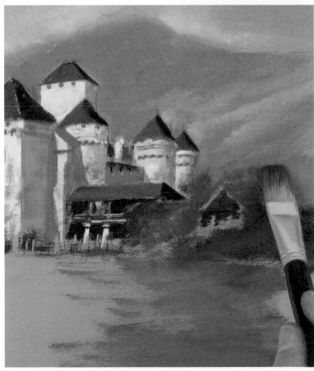

Now the main shape of the mountains is in place, start to give them some colour. Mix ultramarine with a little violet and some white and a touch of Payne's gray to tone it down so that it is not too bright.

RIGHT Thin this colour down with some turpentine, then start to work it carefully around the buildings. You may need to use a smaller brush than the fan brush being used in this photograph.

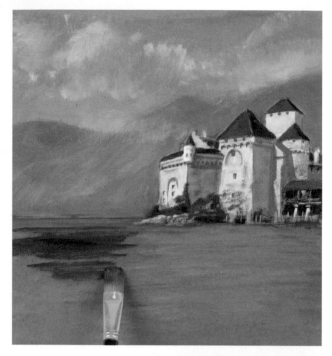

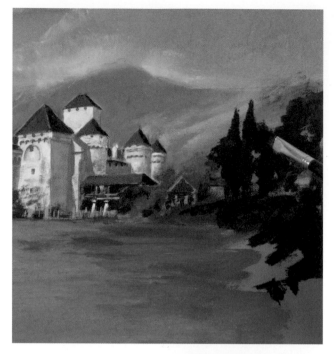

Use the same ultramarine and violet mix on the water, to echo the colour of the mountain. This mix is slightly stronger for the lake, but almost the same colour. Scrubbing in colour to start with gives you an indication of the general tone. Then drag some of the mountain colour into the trees.

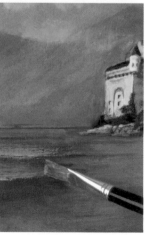

RIGHT Dip the brush in a mix of linseed oil and turpentine and scrub this across the lake. This is almost the consistency of watercolour. Add some white to the ultramarine and work some of this into the left of the lake.

The right-hand side of the painting is important, so concentrate on the colour here. Use a no. 8 flat hoghair brush and build up some trees on the right. Use a mix of viridian and cadmium yellow with a touch of ultramarine, for a strong green. Gradually push this thick paint up into the area of the mountains. This immediately causes the mountains to recede. Dragging the side of the brush on the canvas will give your trees a varied profile. Leave some holes in the green for the mountains to show through.

REFLECTIONS

No ripple or reflection is ever fixed, as water is constantly moving. Rely on the feeling of the brush in your hand and if you see an effect you like, keep it. Remember that reflections are always darker than the objects they are reflecting, so in this painting, for example, Payne's gray was added to colour mix used for the castle to create the reflections of the castle in the water.

RIGHT Now it is time to deal with the reflections in the water. You need to mix a colour for the darks, so take Payne's gray and ultramarine and using the grain of the canvas as guides, drag down to show where the dark areas of the buildings have been reflected. Scrub the colour from side to side in rapid strokes, to help get the effect of moving water. There is no white in the mix at this stage.

Take your fan brush and soften all the paint you have just added into the water. The thicker the paint, the more immediate the effect of the fan.

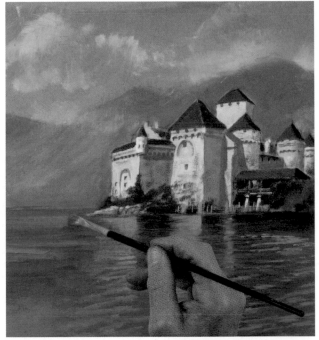

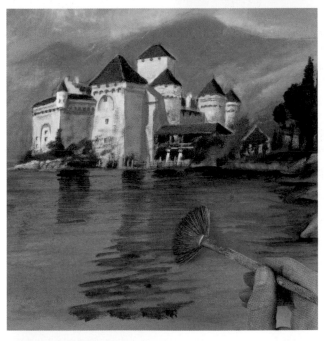

Get some movement into the water on the right by working a mix of ultramarine and white in a side-to-side manner. Then add more ultramarine to the mix and work this into the violet on the left, which now looks too strong.

RIGHT Use a fine sable rigger to work the finials on the buildings. Use thin paint and the mahl stick so that you don't touch the canvas. The finials are more convincing if they are less distinct rather than hard lines. Finally, tidy up the roofs a little by softening off some of the brushstrokes.

STEP 19 ▶▶

STEP 20

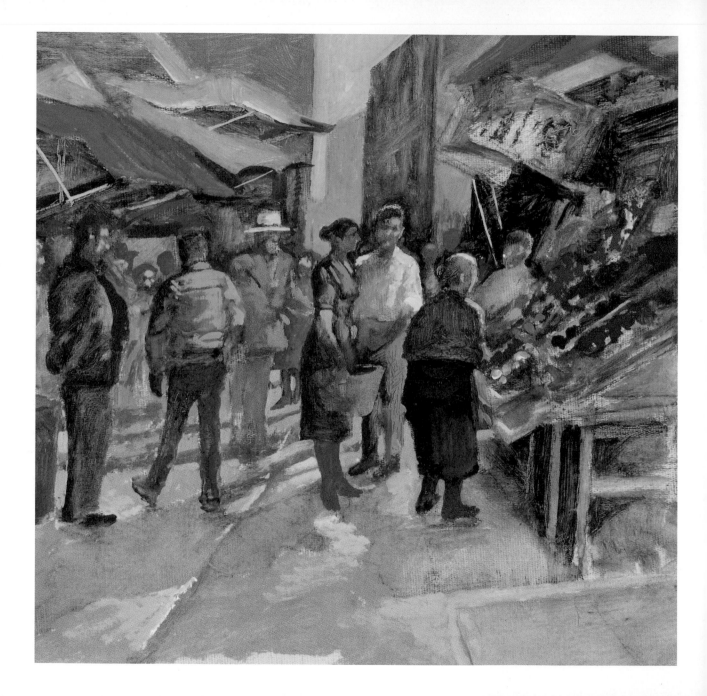

italian market

john barber
240 x 300 mm (9½ x 12 in)

This project demonstrates that accurate figure drawing skills are not vital to creating paintings featuring people. The figures here are all created from simple shapes and refined during the course of the project. Note too that only one figure, the man on the left with his back toward the viewer, appears to be moving – all the other figures are stationary. They work in this scene partly because there are very strong perspective lines holding the whole work together: the lines of the stalls, fruit and vegetable boxes, awnings, the street itself and the buildings all draw the eye into the painting. This project is worked out in monochrome, with colours lightened as it progresses.

WHAT YOU WILL NEED

Canvas panel
Black chalk
Brushes: flat hoghairs nos 1, 3 and 5; round sables nos 2 and 3
Linseed oil, turpentine
Mahl stick

COLOUR MIXES

1 **Payne's gray**
2 **Viridian**
3 **Burnt sienna**
4 **Yellow ochre**
6 **Cadmium yellow**
8 **Cadmium red**
10 **Violet**
11 **Cobalt blue**
12 **Ultramarine**

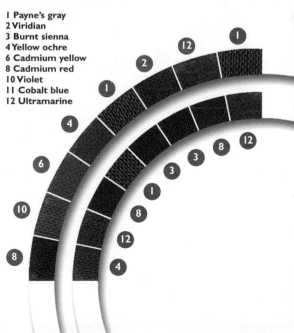

TECHNIQUES FOR THE PROJECT

Creating a silhouette

Working in monochrome

Using perspective

THE IMPORTANCE OF THE SILHOUETTE

If you can establish believable silhouettes, you will be able to add figures into your paintings, which will give them a whole new dimension. You do not have to be a skilled draftsman to do this: as you work through the project that follows, you will note that the edges of the silhouettes are not tidied up until the painting is very well established. In addition, the figures are created from basic shapes: a skirt is a triangle and legs and feet are painted together as one shape to start with. To simplify the drawing elements further, there are no detailed facial features in the painting: the scale is such that they would not read. Also, they are tricky to make convincing.

In the project that follows, a scene peopled with shoppers in a busy market, the silhouettes of the figures are built up as shown and described here, but the project works from dark to light, with shadows created first and lighter tones added later. The technique of outlining the silhouettes of the figures is the same, however. As well as making similar studies to the one here for yourself, it is worth practising front, side and three-quarter views of both male and female figures so you can work out how light and shade affect them. Keep them simple: don't get too involved with clothing details or hair, simply work with different shapes, light and shade.

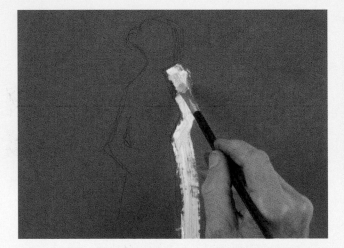

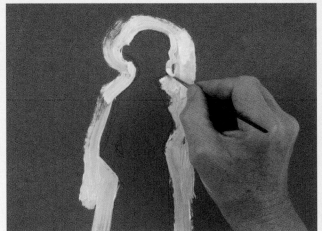

1 On a tinted ground, use pure white paint and a stiff hoghair brush to make your first mark. This can be fairly sketchy, but keep in mind the shape of a female figure and make even your initial marks contribute to the overall shape.

2 Work around the figure, outlining a head, with a hint of a hairstyle and down the arm with its bent elbow and back and around the legs. Then take a smaller brush and overpaint around the face, to give a delicate profile to the nose and chin.

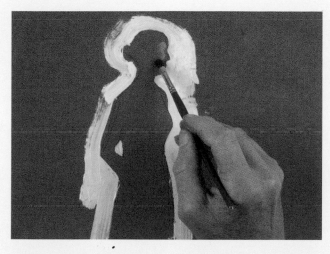

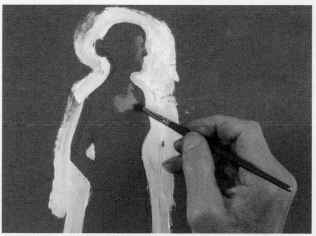

3 Add a little outline colour to create the profile of her elbow. The figure is now cut out from the background. Take a smaller brush and start to add detail. Blend a little colour into her face to indicate where the highlights are and blend its edge.

4 Once you have established where the light falls on her face, working out where the light will fall on the rest of the body is fairly straightforward. On this three-quarter profile, there will be an area of highlight on her chest, so add that in.

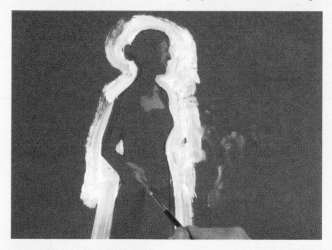

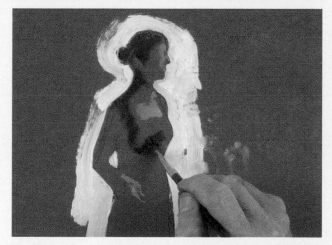

5 Continue down the body. The light will fall on her right hand, so add this. The highlight here gives an indication of the hand too. There will be further highlights in the areas on the right-hand side of her body, so indicate these too.

6 Create shadows using a darker tone of the background colour on a clean brush. Start at the head, where the darker shade will create an indication of a hairline too. Then work down her neck and the rest of the body.

8
italian market

Sketch out the main lines using chalk. Then use the side of the chalk to create an initial idea of where the main areas of light and shade fall. Here the figure on the left is one of the darkest elements in the composition. Reinforce the shapes of the figures on the dark areas. Rub the chalk with your fingertips to create the darker tones. When you start to apply paint, the chalk lines will blend in and become part of the modelling.

SIMPLIFY, SIMPLIFY

This is a complex subject and the essential thing to do is to simplify. Grouping of figures, perspective, light and shade all need careful handling here. Note where the light is coming from. In this case it is coming from high on the right, so that gives dark areas behind the figures and that helps in organising light and shade in the whole work.

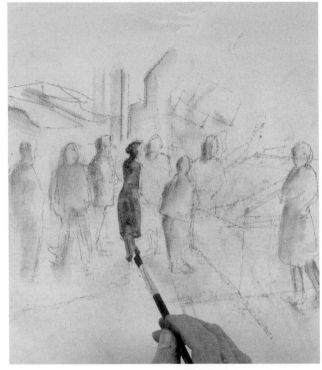

Mix Payne's gray and ultramarine with a little burnt sienna to a wash consistency to establish the silhouette lines. Start with a flat no. 6 hoghair brush. As the painting progresses, smaller brushes will be used.

RIGHT At this stage don't worry about the edges of the silhouette: concentrate on the basic shapes. Do the legs and feet as one shape, for example. Scrub paint in to the figures and the main areas of shadow.

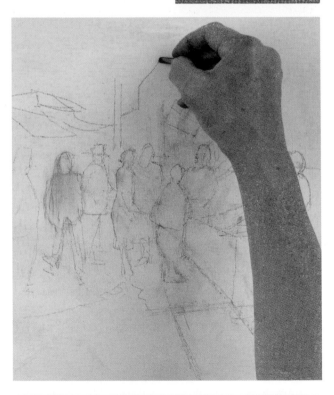

STEP 1

STEP 2

8
italian market

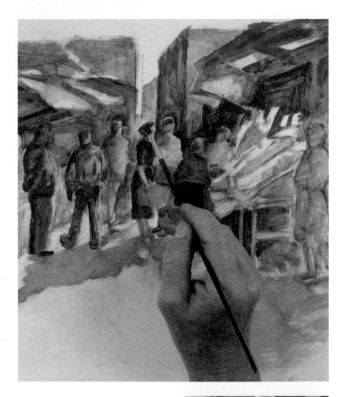

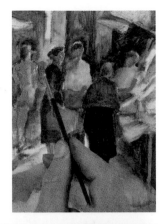

RIGHT To give you a flesh tone, add a touch of cadmium red to the mix. This will create highlights on the areas of skin. Work over the whole painting, establishing all the areas of flesh tone.

Take a mix of ultramarine and white and add some detailed touches. Then mix white with a little yellow ochre and give the figure on the left a Panama hat. The figure next to him has a blue-grey jacket, so mix ultramarine and Payne's gray for that.

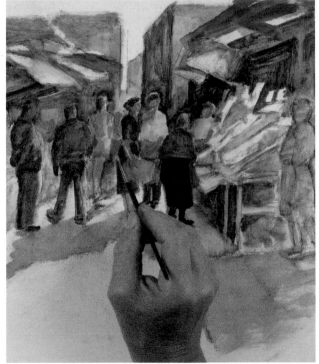

Put in the shape of the woman's hair, which defines her head. It is now time to start adding whites to your colour mixes, so wash out all the brushes.

RIGHT Add some yellow ochre, white and a touch of Payne's gray to give a sandy colour for the suit of the man on the right. Look at where the light is falling: the sleeve cuts out the shape of the figure standing closer to the viewer.

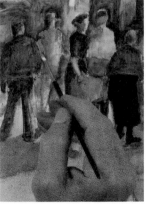

STEP 9 ▸▸

STEP 10 ▸▸

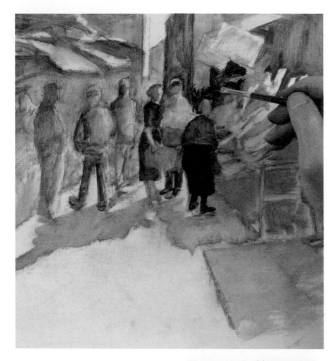

RIGHT Work the stallholder's trousers, then add a little more Payne's gray to work the darker leg and his hair.

Add more burnt sienna to the shadow mix to give a warm tone for marking in some of the detail. Work the arms behind the man on the left with his back to the viewer. Using a small brush on its edge gives even smaller detailed shapes. Take some paint off using a dry brush when you want to even up the tones in the shadow.

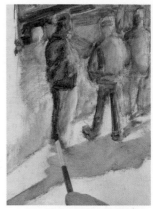

The same colour mix is used for the legs of the figure next to her and the legs of the man on the left, to get some modelling on his legs. He is the only figure who is moving. Use the same colour for the legs of the central man: here it has picked up the colour beneath so it has been modified slightly. Scrub some darker colour into the background to get a sense that there is a building there.

RIGHT Draw the edge of the building in the background fairly precisely between the two heads.

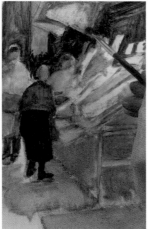

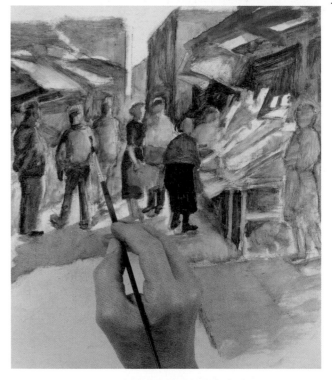

STEP 7 ▶▶

STEP 8 ▶▶

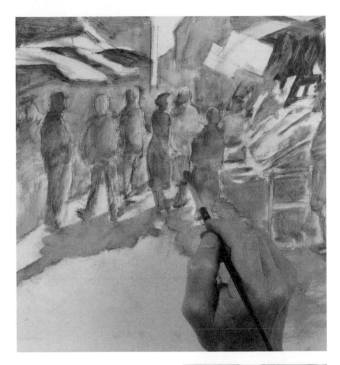

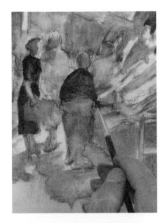

RIGHT Using a no. 3 and a no. 2 brush, start to add flat touches of paint, without blending, to the figures. Take some cadmium red and add it to the background colour and use it for the central figure silhouetted against the light. Take some painting medium and add a little viridian and drag the stiff paint onto the second figure's shawl. The exact colour is less important than the shawl's shape.

Use a mix of Payne's gray and burnt sienna for her skirt and legs.

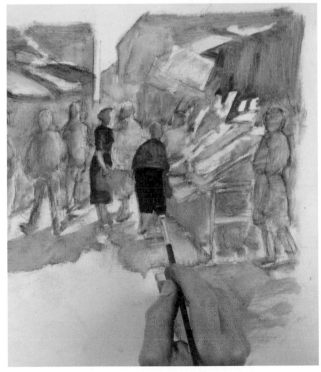

The areas of white canvas that remain (most are now covered) will be the lightest areas of the painting. Rub a light wash over them: they will register better against the tones if you have a little paint on the canvas already. Smudge colours using a dry brush.

RIGHT Introduce some darker tones, beginning with the central figure and working out. Lift out the area where her arm is with a little turpentine. Then lift out some colour from the shoulder and arm of the man on the left, to define him better.

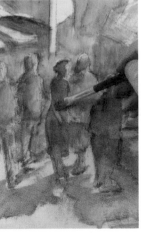

Toward the foreground, where the shadow of the stall is cast, there is a gap between two stalls, where there is an area of light. This will be important in the finished painting. Take a rag and take some paint off the shadows so that they lose some texture. By using quite a lot of turpentine in the mix you get a smooth wash, almost like watercolour. Keeping your shadows as transparent as possible and using white for highlights makes your oil paintings more convincing.

PAINTING MEDIUM

Always use as little liquid with your oil colours as you can: use only what you need to move the paint as much as you want. For this painting, the medium is turpentine, with a little linseed oil, in the proportion one third linseed oil to two thirds turpentine. This gives a smooth, washy consistency.

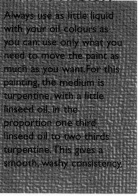

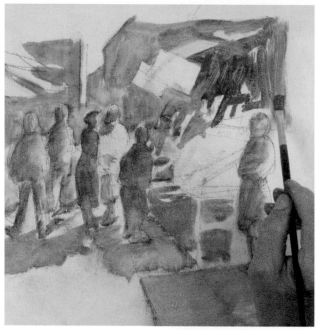

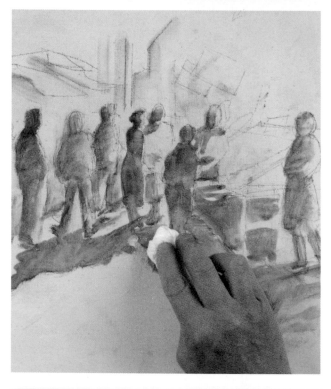

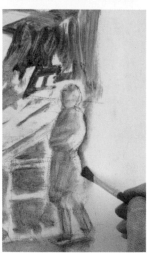

Add more ultramarine to your mix to fill in some of the darker spaces, such as under the awning. Gradually the tonal picture is built up. Adding more blue makes the shadows cooler and highlights the warmer tones of the figures.

RIGHT Start to add more details, including the posters, fruit boxes and the shopfront. Block in the awning and add in the edges of the boxes, since they contribute to the perspective of the whole painting. Define the right-hand edges of the painting: there is a dark edge around the figure and down into the stall.

STEP 3 ▶▶

STEP 4 ▶▶

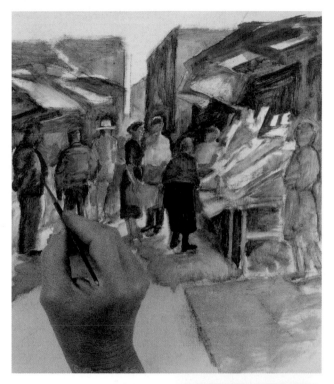

RIGHT Mix more white into the flesh colour and use this to add highlights onto the faces. Then add a highlight to the arm of the central figure.

Drag some pure white into the hair: that is the only colour it needs. Use pure white to indicate where the pale shirt in the centre is catching the light.

The figure on the left has a red shirt, so mix some cadmium yellow and cadmium red for that.

RIGHT Take the sable brush with a little medium on it and blend colour onto the jacket of the man with the hat. Then work some detail into the background to set the figure back a little. Continue to blend using sable and medium to get areas that are in or out of focus. Redefine one or two areas where feet are showing between the figures.

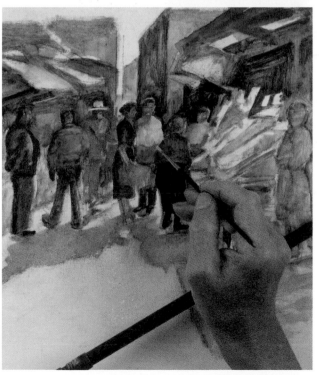

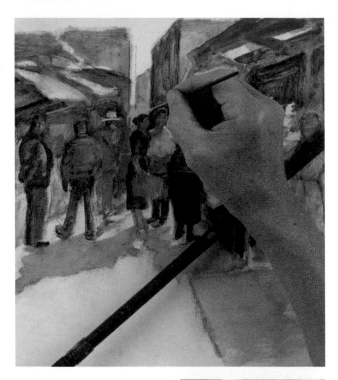

Then scrub the same colour into the area of the stall displaying fruit and vegetables. Mix some cadmium red and cadmium yellow for further areas of fruits and vegetables. The marks here can be quite random, but to retain the perspective, they must stay within their delineated rectangles. Mix violet and ultramarine to add purple touches to the fruit and vegetables: these could be beets or eggplants. Then dab on some pure lemon yellow.

USING A MAHL STICK

Use a cane or straight edge to steady your hand when working fine detail. This keeps your hand off the painting. On a large work, a stick with padding at the ends, known as a mahl stick, stops the stick from resting on the painting, thereby preventing paint from being moved around unintentionally. The mahl stick is shown in use in the photograph on the left.

Use the darkest background colour to change the shape of the head of the character in the centre. In oil painting one colour is constantly 'cutting' into another. Add a little viridian to pure white and use this for a highlight on the woman's shawl. Use the same colour to define the tummy and arm of the man on the left and also between the central figures to define them as separate.

RIGHT This colour is also used for one of the awnings.

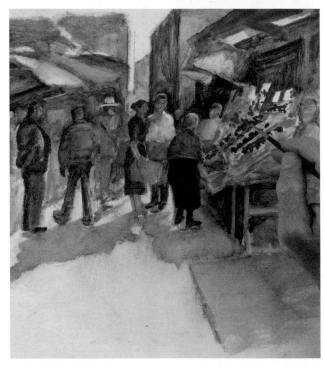

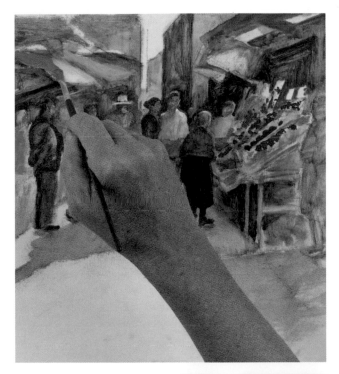

Bring a little light into the top of the wall on the right. Mix some white and cobalt blue to create the colour for the sky. Touch some burnt sienna into the cobalt blue mix to warm it and use this to cut out a little detail at the bottom of the sky area. Drag a little blue-grey into the edge of the awning at the top, where it cuts into the sky and then bring in some shadow.

CHOICE OF MEDIUMS

The painting medium you choose influences how a work develops. Because turpentine was used for the monochrome shades in this project, they dried fairly quickly, to give a good basis on which to begin to add white paint. Adding some linseed oil also means that you work into wet paint, picking up some background colour to modify whichever colour you are applying.

Mix some cadmium red and yellow ochre for the awning on the left. Apply this using a no. 4 hoghair brush. Use the same colour for the awning on the right. Because this is painted over the darker shadow tone, it mixes on the canvas to create a new colour.

RIGHT Use the awning colour to give an indication of type on the banner. Break this up with the end of the brush handle. Then use the mid-grey to give an indication of windows. This area is now looking less harsh.

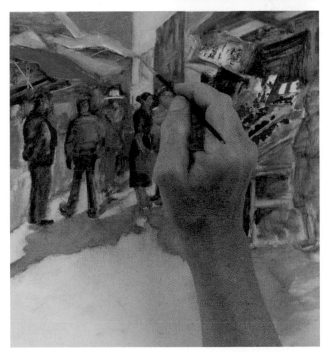

STEP 15 ▶▶

STEP 16 ▶▶

8
italian market

RIGHT Touch up the darker areas to give them greater definition. Use the brush and Payne's gray as a drawing tool. Blend with a dry soft sable brush. Use the same soft brush to lift some highlights from the woman's red dress. Used on its own cadmium red dries quite slowly, so it is still easy to do at this stage.

Add a dark grey crescent, around the pale grey shape. This has the effect of turning the shape into a head, outlined with hair.

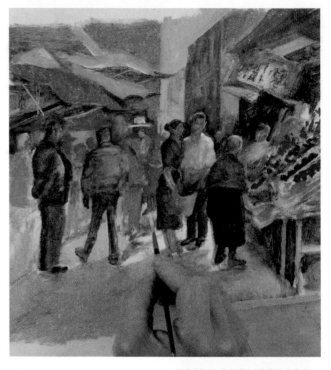

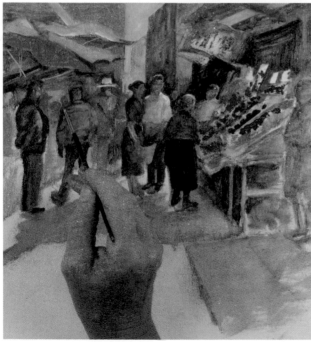

It is now time to start to fill in the foreground. It is important to use plenty of white in your mix, so that you can cut out the feet and their shadows. Mix white, yellow ochre to warm it and a touch of cadmium red. The first colour mix looked too pink, so a little Payne's gray, a touch more cadmium red and more white were added. Use a hog brush for the larger areas, then switch to a sable for the areas of detail. Keeping the paint quite liquid, switch to the sable for the details.

TRICK OF THE TRADE

If your paint builds up too thickly in one area, you can place a piece of rag or kitchen paper over the area. Press down firmly then peel off carefully. You will be left with a paler version of the subject, ideal to repaint over.

RIGHT You can pull a little white into shadow areas, but take care not to overdo it. Then add one or two touches of foreground colour to the background to liven it up.

Modify the colour on the woman's arm which is looking too light now and improve the colour of the basket. Mix up some Payne's gray and white and do some modelling, paying attention to the legs and feet. Brighten up the lady in the shawl to give her a lift. There are only three marks here: two on her face and one on the shawl.

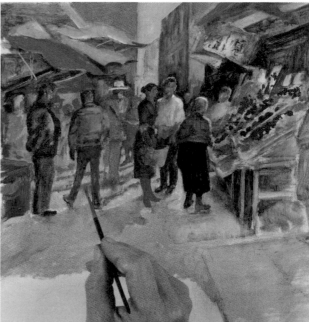

Use the pale grey mix to eliminate any remaining areas of canvas on the left. Even things you can't see cast shadows, so now that the painting is nearly finished it is clear that there should be more shadows in the central area to make the angle of the light more convincing. Then indicate a gutter to give another line to lead the eye into the painting.

RIGHT When the painting was 'finished', it was apparent that the fruit and vegetables should be in more shadow. When the paint was dry, these were glazed over to knock them back.

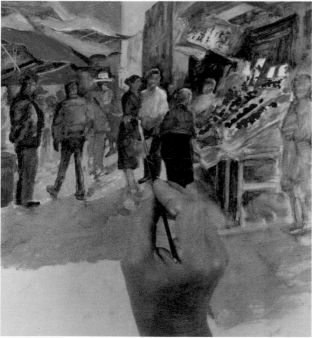

STEP 19 ▶▶

STEP 20

index

index

Picture credits
All artworks by John Barber except: pp. 40–49 © as credited to individual artists.

Author's acknowledgments
I would like to thank my wife, Theresa, for her loving support during the countless hours I spent in the studio preparing this book.

Publisher's acknowledgments
Axis Publishing would like to thank London Art Limited, 132 Finchley Road, London NW3 5HS for the loan of materials for photography.
www.londonart-shop.co.uk